IMAGES
of America

AROUND
ROCKLAND

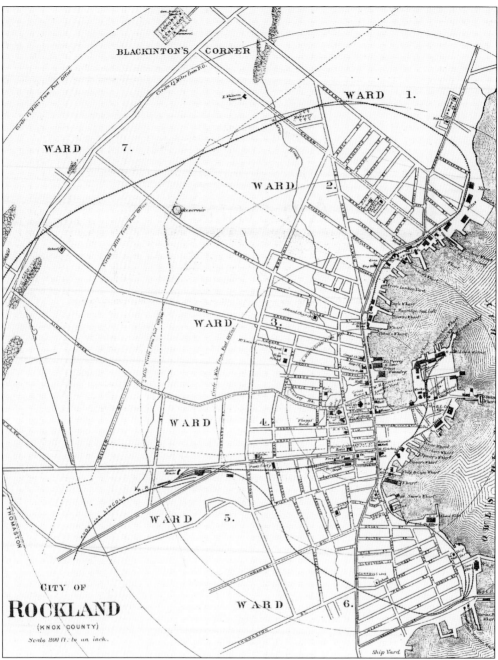

A map of Rockland from the early 1890s showing the complete route of the Limerock Railroad as well as important public buildings and commercial wharves.

IMAGES
of America

AROUND
ROCKLAND

Shore Village Historical Society

ARCADIA
PUBLISHING

Copyright © 1996 by Shore Village Historical Society
ISBN 0-7385-4942-8

Published by Arcadia Publishing
Charleston SC, Chicago IL, Portsmouth NH, San Francisco CA

Printed in the United States of America

Library of Congress Catalog Card Number: 2006932346

For all general information contact Arcadia Publishing at:
Telephone 843-853-2070
Fax 843-853-0044
E-mail sales@arcadiapublishing.com
For customer service and orders:
Toll-Free 1-888-313-2665

Visit us on the Internet at http://www.arcadiapublishing.com

Cover Photograph: A detail from the illustration on p. 14. This photograph shows the earliest method of transporting lime rock from the quarries to kilns on the waterfront.

Contents

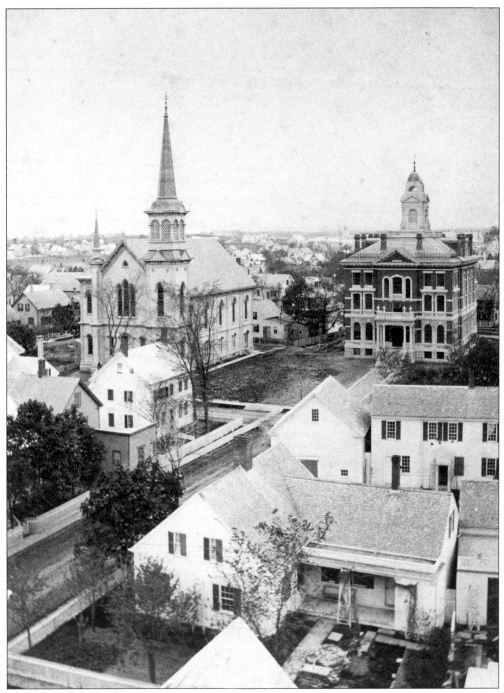

This stereoscopic view is from the top of the post office and customs house looking southwest. It illustrates Rockland's long-time prominence as a center of commerce, shown by the buildings in the foreground; as a center of government, shown by the Knox County Courthouse on the right; as a center of religious activity, shown by the Universalist Church of Immanuel on the left; and as the Midcoast's population center, shown by the houses spreading out beyond.

Introduction

Rockland, Maine, has benefited from a fortunate combination of geography and economics that has insured its viability through nearly 230 years of history. Our harbor is huge and shaped like a perfect half-moon. A 4,300-foot granite breakwater protects it from the northeast while Owls Head helps buffer wind and tide from the southeast. Its location, about half-way between Kittery and Eastport, has given us the designation "Midcoast Maine." Rockland began in the mid-1760s as a tiny settlement east of Thomaston called "The Shore." Within eighty years that small village of less than a dozen founding families had grown to become the fifth largest city in Maine and the premier lime-producing port of the United States. The quarrying, burning, and shipping of limestone for plaster was big business a hundred years ago and Rockland lime was known the world over for its quality. Often affiliated with the lime trade, shipbuilding at numerous yards created vessels that sailed all seven seas. Among these was *Red Jacket*, a clipper ship so fast her record speed to Liverpool, England, has never been equalled by a ship under sail.

At the same time industry was keeping Rockland economically strong, other forces were insuring its longevity. In 1854, when Rockland became Maine's eighth incorporated city, we already had a half-mile-long downtown commercial district. In 1860 Knox County split off from Lincoln County, and Rockland was named the new county seat, bringing courts, offices, and services to our city. In addition to being the industrial center of the Midcoast, Rockland became the commercial and governmental center at the same time. But nothing lasts forever, and the other characteristic that has helped Rockland survive and prosper has been adaptability. When wallboard replaced plaster in the building trade, the local lime industry was devastated. By then, however, Rockland had already begun to commercially process sardines and other fish and was shipping lobsters to markets all over New England. Our shipyards changed from building lime or fuel-carrying vessels to building and maintaining fishing boats.

In recent years, as the commercial fishing industry has suffered problems of regulation and supply, Rockland has again begun to adapt. Several new marinas for recreational boats have opened on the harbor, and the city has become the center of the windjammer trade with as many as a dozen schooners taking passengers on sailing vacations around Penobscot Bay. From lime, to shipbuilding, to commercial fishing, to recreational boats and tourism, the keys to Rockland's survival and success have always been realism and adaptability. Ours has always been a down-to-earth, hard-working community, progressing sensibly toward realistic goals with little fanfare and with a desire to retain and share the beauty of our environment as we have developed our commercial potential.

This book does not, in any way, pretend to be a history of our community, but seeks to share many previously unpublished photographs from the period of about 1860 to 1960. We have arranged the material to follow a progression from industrial and commercial interests to celebrations and groups posing for the camera. By adding this title to the Images of America series of local accounts, we hope to build on the historical material already made available to area people through the *Shore Village Story*, the *Shore Village Album*, *Home Front on Penobscot Bay*, and, most recently, *Steamboats, Sleighbells And A One-Man Band*. The preservation of local history is important to help our communities keep their character, to give our citizens a sense of belonging to the place where they live, and to teach our children the values of preservation and careful use. Rockland, Maine, has a productive past and a rich heritage of which we are proud. We hope to continue the process of defining that past and sharing it with everyone who wants to learn about it. We hope works like this series of regional portraits will stimulate others to write more about Rockland and aspects of its history, and, most of all, we hope that you enjoy the presentation we have chosen for this work. It is sometimes serious and sometimes lighthearted and should prove to be entertaining but, most importantly, educational for those who enjoy history.

Brian Harden
Barbara Perkins
November 1995

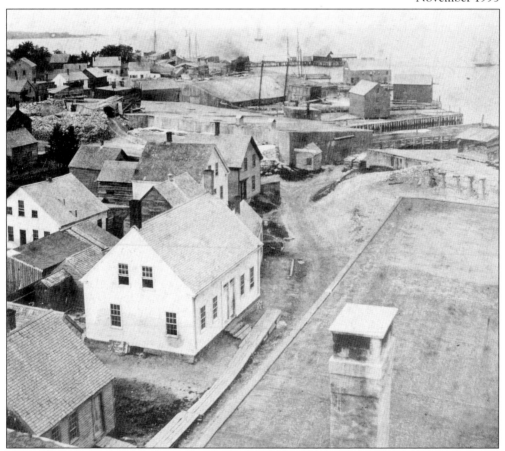

This 1880s view, from a stereoscopic slide, shows Rockland Harbor looking northeast from the top of the Lynde Hotel. This hotel was on the corner of Park and Main Streets.

One

A Working Harbor

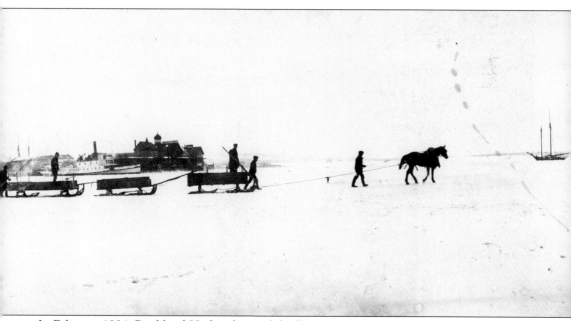

In February 1904, Rockland Harbor froze solid, allowing people to walk or ride to Vinalhaven or Owls Head over the ice. A coal shortage developed in the city and this photograph shows a group of three sleds, called pungs, being pulled out to unload coal from an ice-bound schooner in the bay. Behind the pungs is Tillson's Wharf with at least two steamboats frozen fast in the ice.

Rockland Harbor is protected by a 4,300-foot granite breakwater constructed between 1888 and 1900, with a light tower and accompanying dwelling erected by the W.H. Glover Company. Rockland Breakwater Light was first lit in 1902.

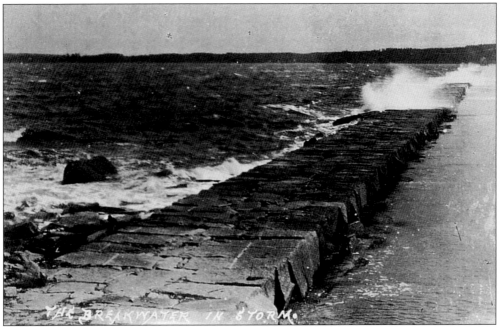

Local historian James Burns wrote: "The fierce storms which were formerly a menace to Rockland shipping, and which during high tides gave the lime manufacturers so much apprehension, now beat in vain their fury against a superb wall of granite inside of whose protection many thousands of craft come to anchor in safety."

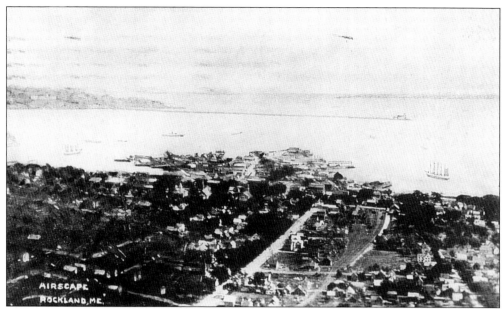

The above image is an old airscape postcard view looking over the city to the harbor with Rockland's breakwater and the Samoset Hotel beyond. In 1924, when this photograph was taken, the waterfront was teeming with commercial activity, especially in the area of Crockett's Point. The photograph below, also a postcard view, was taken about 1902 and shows the harbor looking back from the Samoset.

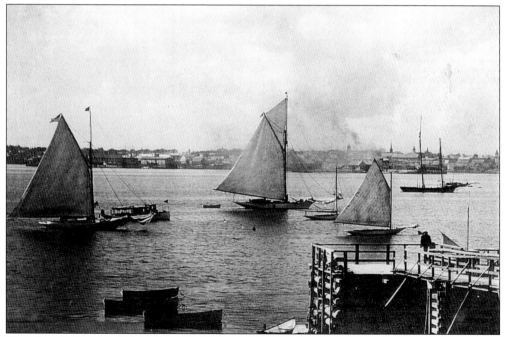

This description was taken from an 1892 publication: "This harbor, with its shore-built city, canopied by day with the 'Terebinthene' smoke, and illuminated at night with the brilliant fires of innumerable lime-kilns, presents a pleasing appearance from the water . . . and is considered by seamen to be one of the safest anchorages on the coast."

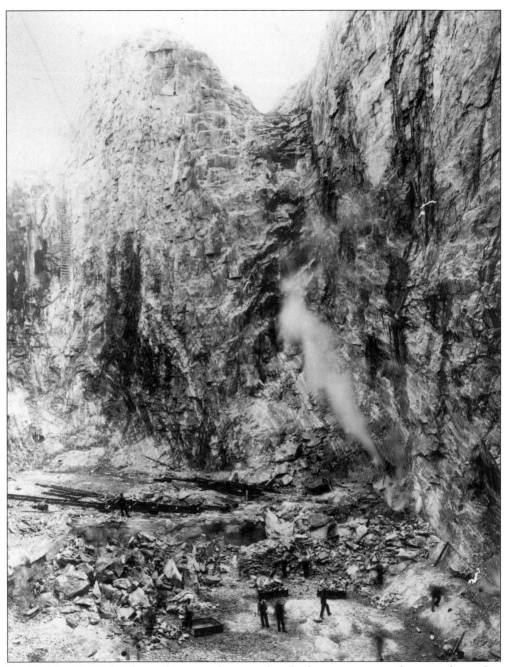

Rockland's principal industry for more than one hundred years was manufacturing lime. Our quarries, just west of the city center, yielded the finest lime rock in the world. Rock transported to kilns on our waterfront was burned and crushed, and the lime could then be used to make plaster and certain types of mortar. The late 1800s and early 1900s saw more than a million casks of lime produced each year. Rockland lime was shipped to all parts of the country until the Depression and the building industry's adoption of wallboard caused the lime industry's downfall. This picture is of the Engine Quarry off Old County Road in the 1890s. The deepest of Rockland's quarries reached at least 375 feet.

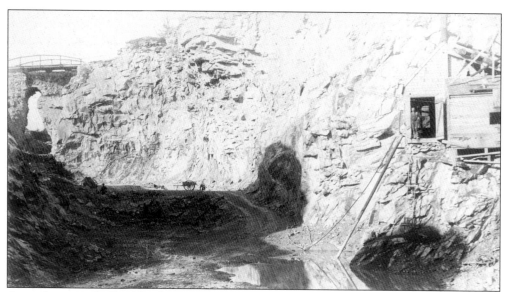

An early view of a Rockland quarry showing the Park Street bridge in the background. The wagon in the center was used to haul rock out of the quarry.

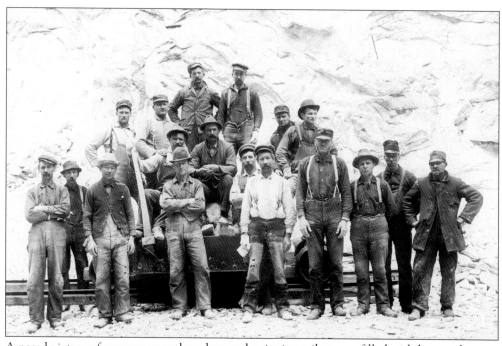

A posed picture of quarrymen gathered around a tipping railway car filled with lime rock.

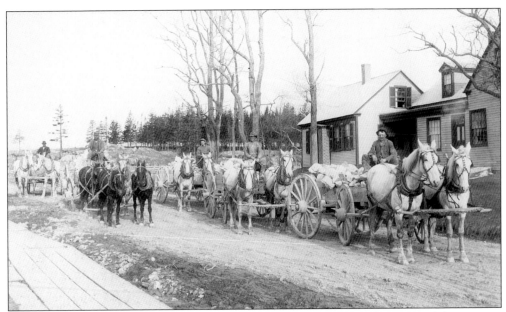

This photograph shows five wagons loaded with limestone en-route from one of the quarries to the kilns near the waterfront. Wagons like these used one of the three most common "lime avenues": Park, Limerock, and Rankin Streets.

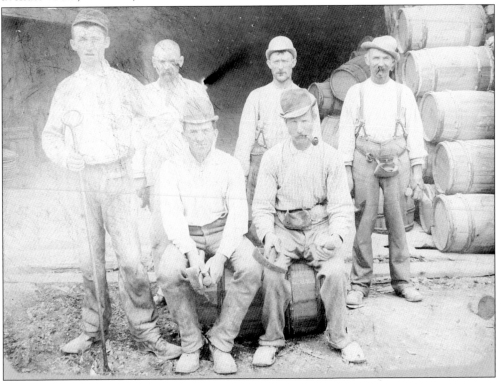

Kiln workers, holding tools of their trade, pose outside a lime shed. The manufacture of casks used to ship lime, such as those in the background, was a related industry in surrounding communities.

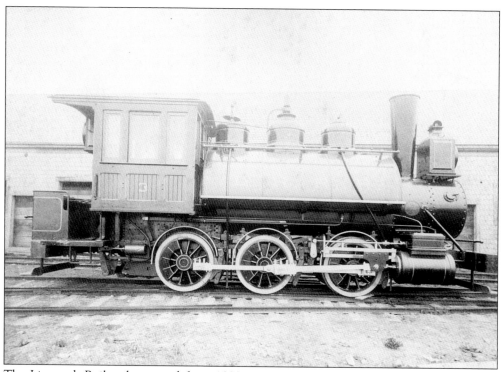

The Limerock Railroad operated from 1888 to 1942 on a maximum of 12.5 miles of track between the quarries and the kilns. This is Engine No. 3.

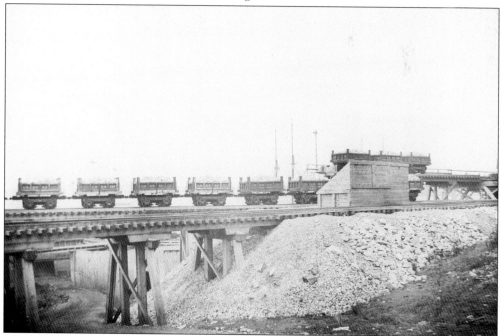

The Limerock Railroad consisted of about five hundred cars, most like those pictured here, and four engines. Track along the waterfront was laid on hard pine trestles. The masts in the background show the proximity of lime kilns to the harbor.

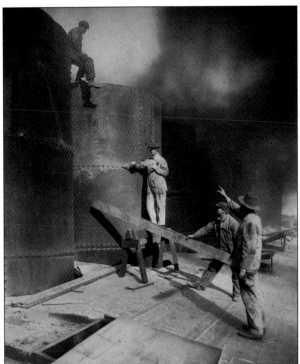

Workers on the kiln chimneys at the Rockland-Rockport Lime Company in the North End. Rivets had to be replaced frequently because of intense heat and constant pressure.

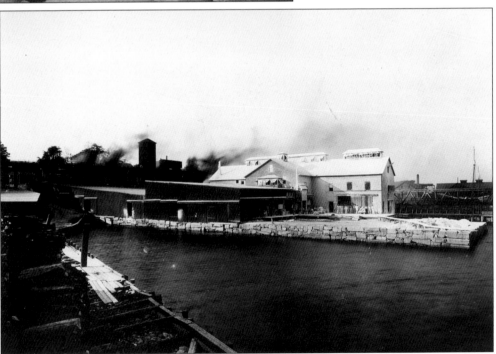

This view of North End kilns and sheds shows the area where the Rockland-Rockport Lime Company consolidated its burning, packaging, and shipping operations in the early 1900s. Note the group of workers just outside the main shed, with smoke from the kilns to the left and ship masts to the right.

An abandoned kiln on the property of the Rockland-Rockport Lime Company near Front Street. These kilns were fueled first by wood and then by coal, which reduced the burning time for a kiln load of limestone from five days to one. They were eventually replaced by the gas kiln pictured below.

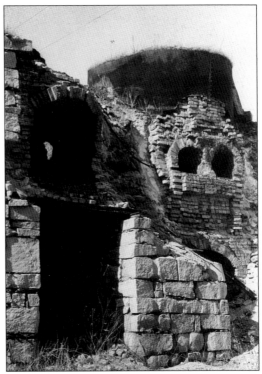

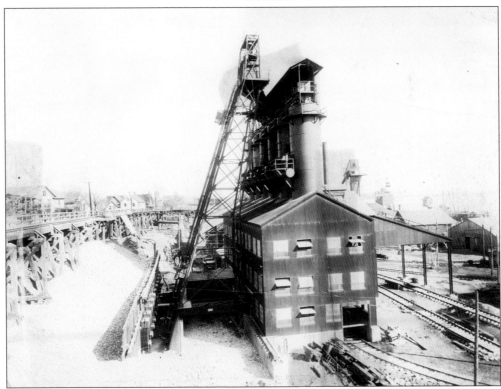

The Rockland-Rockport Lime Company gas kiln, completed in 1921.

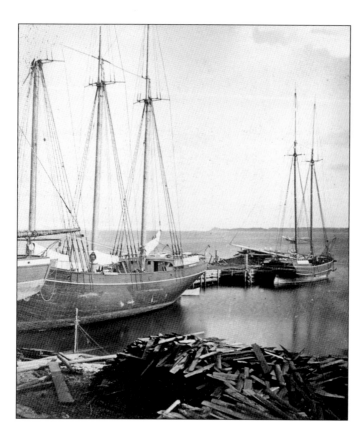

An 1870s view of Rockland's harbor from the railway wharf in the South End.

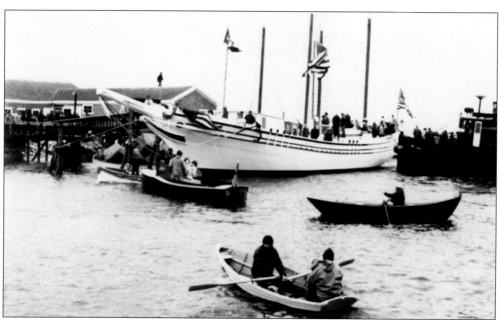

Rockland's shipbuilding tradition continues today. This is the launching of the schooner *Heritage* on April 16, 1983. Designed and built by Captain Douglas Lee of Rockland as a commercial passenger vessel, she is modeled after the coasting schooners of the late nineteenth century.

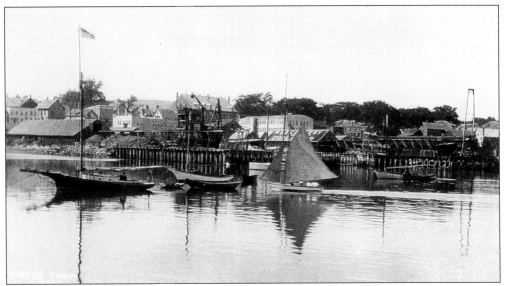

A view of the northern area of the harbor with two landmark buildings in the center: the Rankin Block and the E.L. Spear Company. The boat under sail is the *Mistake*, built by Captain John I. Snow.

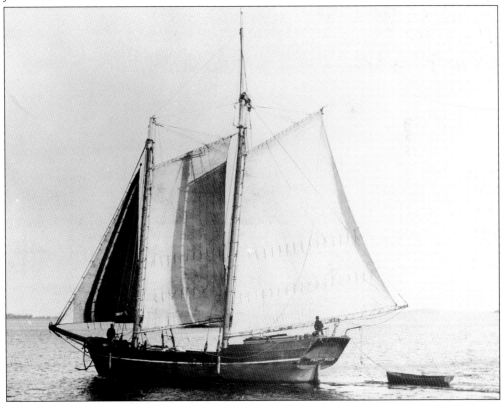

The *Polly*, called the champion of all coasters, was built in 1805. Although the legend that she was a privateer in the War of 1812 has been proven false, her active career carrying lumber, lime, and stone stretched from before that war to the end of World War I in 1918.

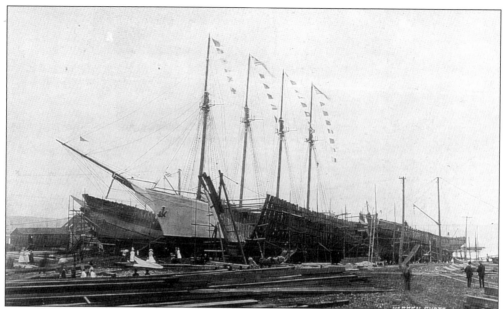

A rare view of four ships being built at the same time at the Cobb-Butler Company Shipyard on Atlantic Street during the summer of 1908. From left to right, the schooners are: the *Lewiston*, the *Jessie A. Bishop*, the *Stanley M. Seaman*, and the *Frank Brainerd*. The *Frank Brainerd* and the *Lewiston* were launched on the same tide in a unique double event; the former at 10:05 am and the latter at 10:25 am on September 24, 1908.

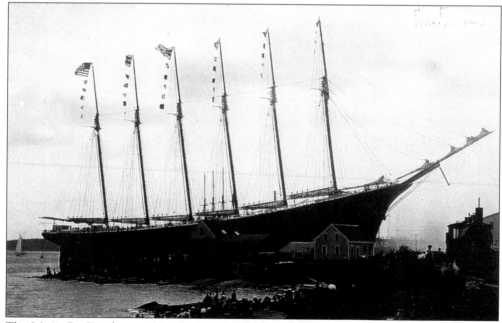

The *Mertie B. Crowley* was launched on Saturday, August 24, 1907, and at 2,824 gross tons, she was the largest vessel built in Rockland. Started at the Bean Yard in Camden, she was disassembled following a financial embarrassment there and brought to Rockland to be completed. She was used in the coastal coal trade, but only lasted three years before she was lost on Nantucket shoals in 1910.

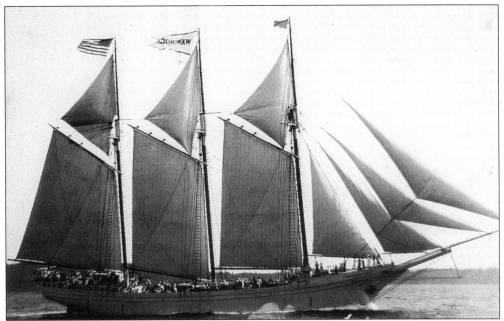

A 1907 postcard view of the *Wawenock*, which was launched in July of that same year from the I.L. Snow Company yard on Mechanic Street. It was traditional for ships to be taken on a shakedown cruise around Rockland Harbor after they had been launched and fitted. The message on this card reads: "Rockland, September 15, 1907. The Wawenock as we saw her from the orchard."

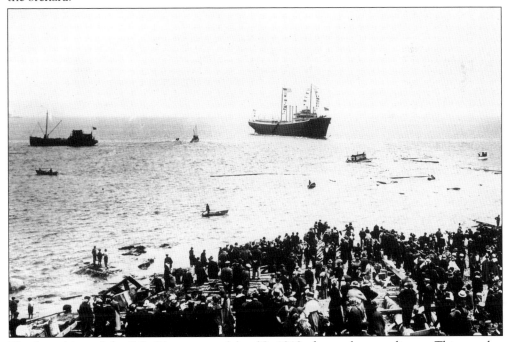

The launching of the S.S. *Ripogenus* on May 29, 1919, drew a large audience. This wooden steamer, owned by the Great Northern Paper Company, had a crew of thirty and used Belfast as its home port.

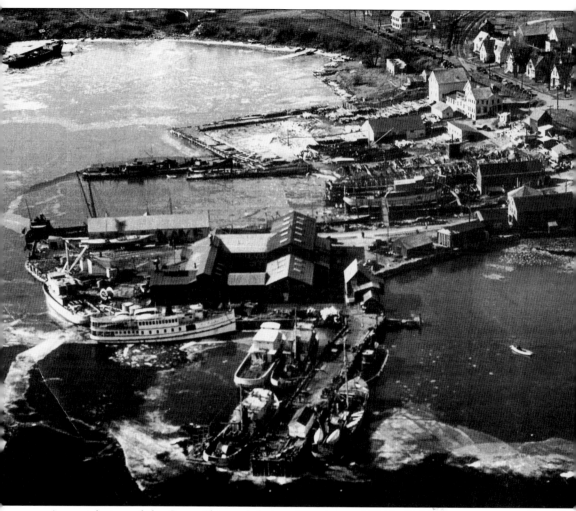

An aerial view of the Snow Shipyard during the winter of 1941–42. Under contract to the federal government to build ships for the war effort, the Snow Yard increased its work force from fifty to more than five hundred as evidenced by the cars parked on both sides of Mechanic Street in the upper portion of the photograph. The older-type steamboat in the left foreground is the *W.S. White*. To its right final work proceeds on one of five mine sweepers. Two 110-foot submarine chasers can be seen under construction on the ways. Just above these vessels lies Burma Road, an area of the shipyard that was filled and used to build net tenders.

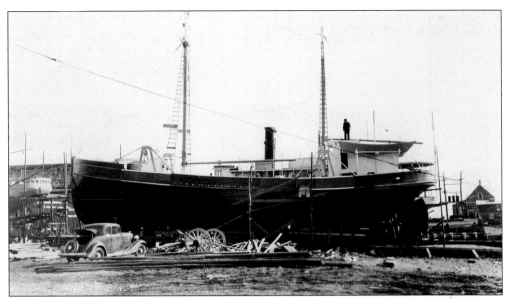

Before World War II, the Snow Yard built ships like this dragger, the 90-foot *Julia Eleanor*, launched in March 1937.

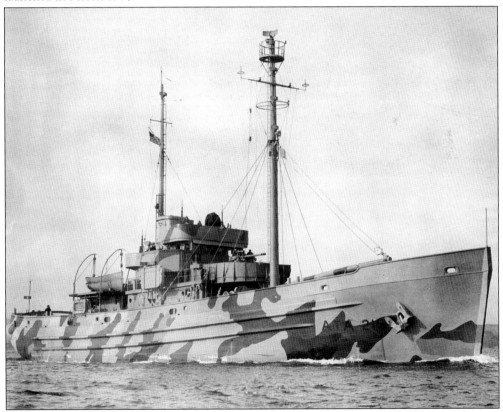

This U.S. Navy fleet tug, ATA 215, was launched in September 1944 from the Snow Shipyard. I.L. Snow and Company received the coveted "E" Award from the government for excellence in assisting with the war effort.

Fishing has influenced Rockland's economy for nearly two hundred years. It was vital to our early residents as a source of food and business. Commercial fishing continues to the present day, although on a much reduced scale. The continuity of Rockland's commercial fishing industry is shown by this small sardine carrier tied up near Tillson's Wharf, with the Coast Guard ice breaker *Kickapoo* in the background.

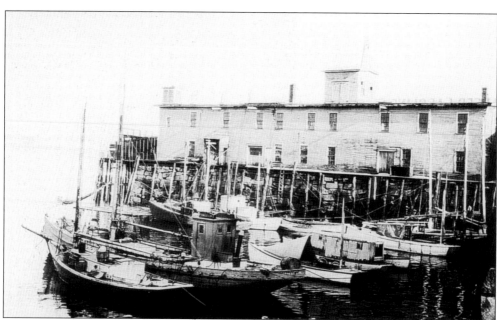

A group of fishing boats north of Tillson's Wharf before the advent of mechanized fishing trawlers.

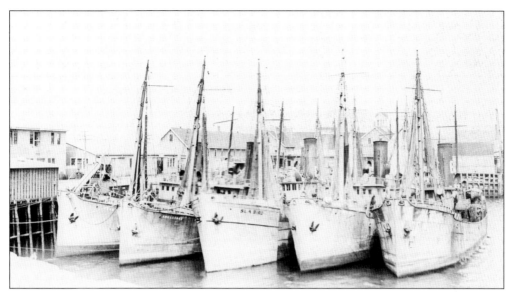

Five steam trawlers, with the *Seabird* in the middle. The big "E" on the stacks designates them as belonging to the East Coast Fisheries, based in Rockland.

Three sardine carriers in approximately the same location as the trawlers at the top of the page. These two views show the change over from Tillson's Wharf (top photograph) to the U.S. Coast Guard station (bottom photograph). On the left is F.J. O'Hara's ice plant.

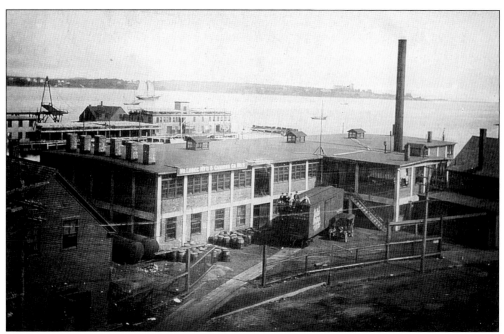

An aerial view of North Lubec Manufacturing and Canning Company No. 5. The "Eagle" brand name used on sardines packed at North Lubec is one of the oldest in the United States.

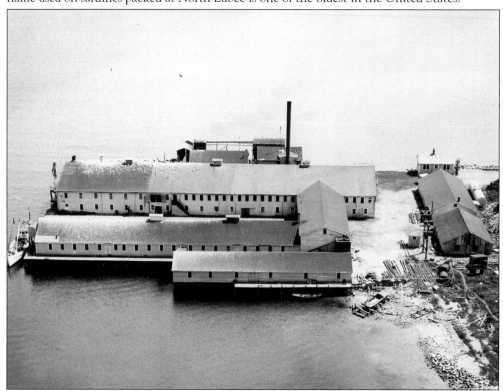

The Holmes Packing Company, a sardine plant near the public landing, burned in January 1985.

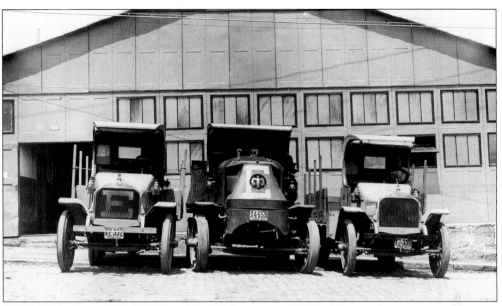

Several delivery trucks of the East Coast Fisheries, in a 1920s photograph.

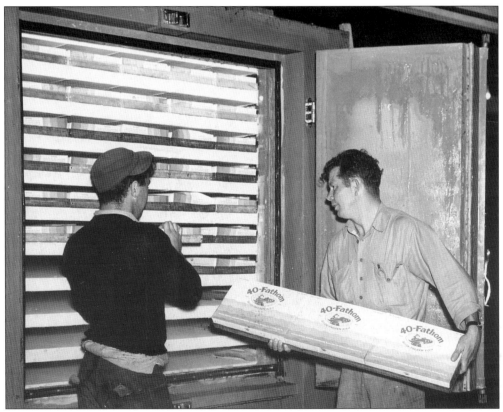

A 1940s photograph of a freezer full of Forty Fathoms frozen fish fillets packed by General Seafoods at their plant on Tillson Avenue.

A postcard notification of lobster prices in September 1933 from the Penobscot Fish Company. Rockland has long claimed to be the "Lobster Capital of the World," and Maine lobsters from this port are considered a delicacy worldwide. Live lobsters were first shipped out by air in 1938 when an order was flown to Rudy Vallee in Hollywood for a dinner party.

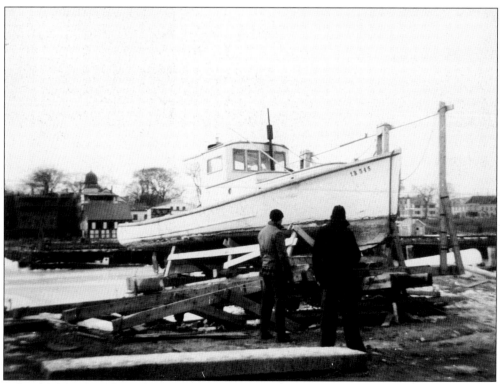

A local lobster boat hauled up for the winter at the Snow Marine Basin on Crockett's Point near the present FMC Marine Products Division plant. Bert Snow stands to the left.

Two

A Center of Commerce

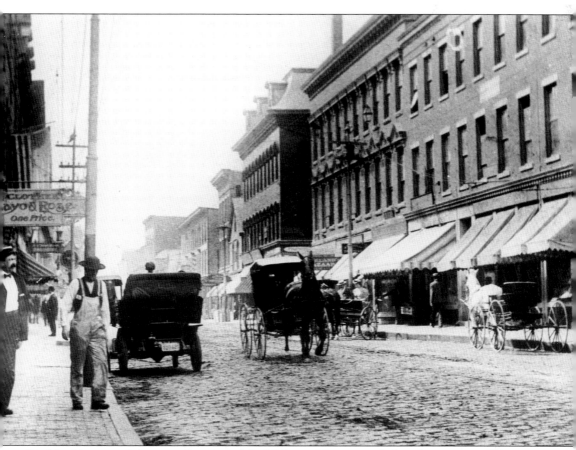

Rockland became the center of commerce for Midcoast Maine even before the creation of Knox County in 1860. By 1910, Main Street was paved with granite blocks, and imposing buildings lined both sides of the street for nearly half a mile. In this photograph, the horse and buggy and the automobile seem equally at home in front of Mayo & Rose Clothiers.

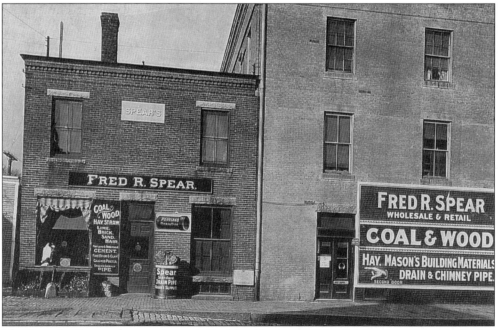

Francis Cobb administered his vast commercial interests from this Main Street office above Rockland National Bank. Besides the Cobb Lime Company, his holdings extended to retail and wholesale trade as well as shipbuilding and marine supplies.

The Spear family was also prominent in Rockland business affairs. Fred R. Spear occupied a tiny business block on Park Street near the corner of Main with his wholesale and retail coal and wood business. This 1917 postcard reads: "I am pleased to quote you egg, stove and nut coal at $14.50 per ton, 50 cents per ton discount for cash."

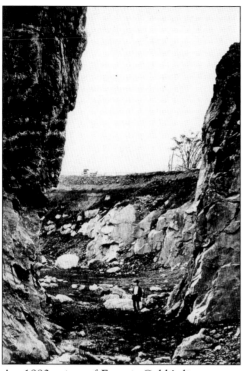

LIME PRODUCTION
OF
ROCKLAND, MAINE.

	1893. BBLS.	1894. BBLS.	1895. BBLS.
F. Cobb & Co - - -	360,558	263,578	352,540
Perry Brothers - - -	153,246	168,662	160,000
A. F. Crockett Co - -	151,478	133,197	181,564
A. J. Bird & Co - -	106,645	114,996	154,152
A. C. Gay & Co - -	45,812	102,518	118,313
Farrand, Spear & Co	73,208	58,900	80,601
Almon Bird - - - -	37,938	33,827	32,940
Joseph Abbott - - -	47,396	40,314	55,000
James T. Tolman - - -	10,000	30,000	8,000
K. C. Rankin & Son	36,380	22,637	30,000
H. O. Gurdy & Co -	53,833	21,915	
C. Doherty - - - - -	25,527	23,621	58,725
John S. Case - - - -	30,963	19,927	28,563
G. A. Ames - - - - -	15,188	19,800	
Sherer & Co - - - -	1,426	1,423	
A. W. Gay & Co - -	60,689		
R. W. Messer - - - -	24,050		
Chas. Pressey - - - -	5,957		
H. D. Ames, - - - -			5,342
	1,240,294	1,055,315	1,265,740

An 1880s view of Francis Cobb's lime quarry near Blackington's Corner. In 1884 the cost of manufacturing 100 casks of lime was said to be $85, figured as follows: value of the rock at quarry—$4.50; labor, including quarrying and hauling, breaking, burning, and putting aboard—$26.50; 100 casks—$20; wood for fires—$16; and freight—$18.

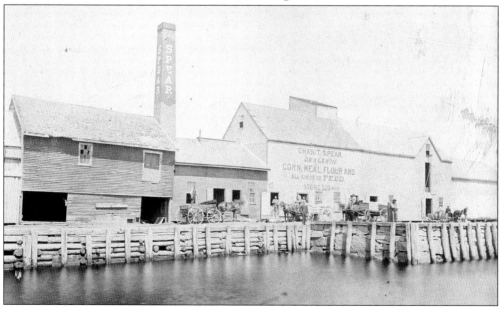

Just east of Fred R. Spear's, beyond the foot of Park Street, was the Spear Commercial Wharf. The part of the wharf shown here served as warehousing for the family's feed business and for other of their enterprises.

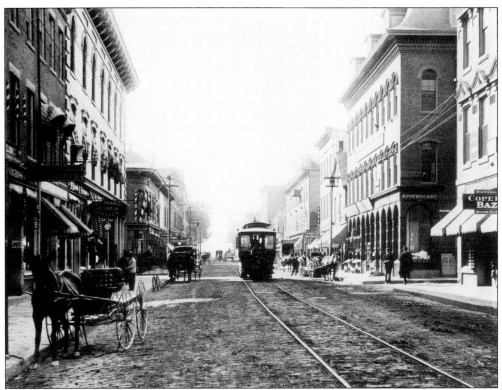

Main Street looking south in 1895. A car of the Rockland-Thomaston & Camden Street Railway passes the Thorndike Hotel on the left. This period, just before the advent of the automobile, shows buggies, wagons, a bicycle, and pedestrians in downtown Rockland.

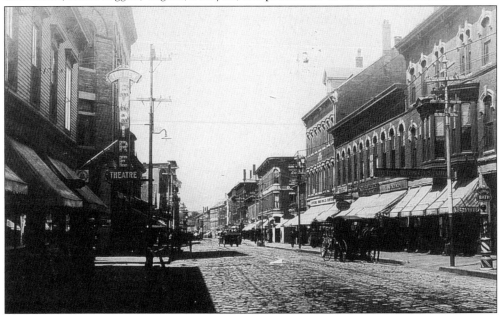

Main Street looking north fifteen years later. Even though the Berry Brothers Stable fills the right foreground, the automobile has already shown up on Main Street.

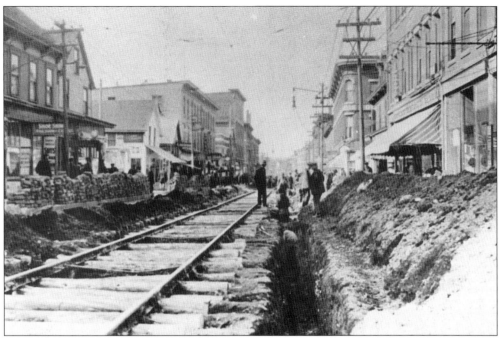

Something always needs fixing. Even major sewer work on Main Street proceeds around the trolley tracks so as not to disrupt service.

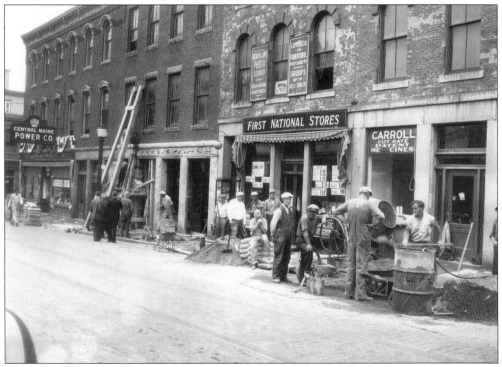

The sidewalk superintendents on the left nearly outnumber the installers on the right. Trade in the First National Stores is not interrupted, but who is minding the baby in the carriage out front?

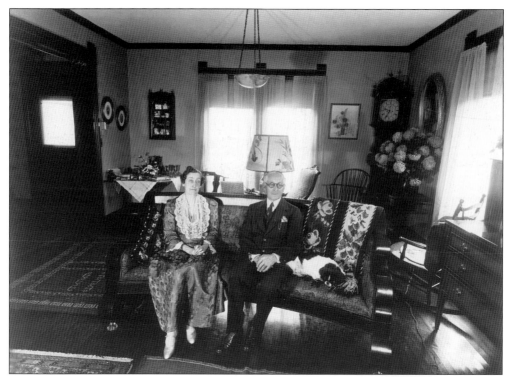

Ernest and Rose Davis at home at 294 Broadway in the 1930s. Mr. Davis' obituary in 1943 called him "one of Rockland's best-known citizens." He serves as an interesting example of a Rockland native who charted a successful career as a business entrepreneur.

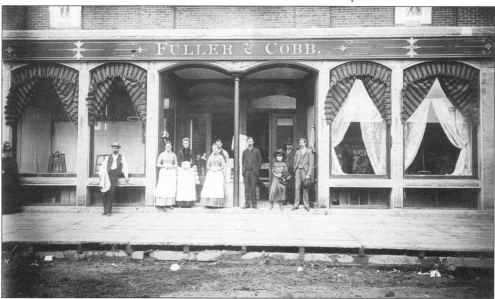

Fuller-Cobb at its second location in the Farwell Opera House building at 460 Main Street near The Brook. Mr. Davis started his commercial career as a clerk in a South End candy store, but by the time Fuller-Cobb moved here from its first location near Park Street, he was already an employee in this growing department store.

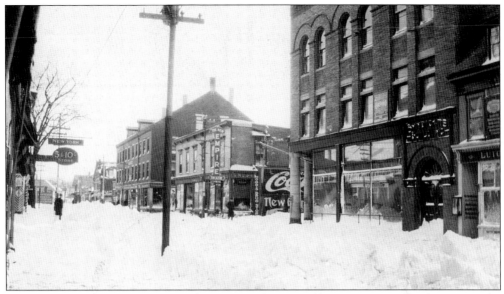

Fuller-Cobb next moved to part of the new Syndicate Building at Main and Oak Streets. The grand opening there was attended by hundreds of Rockland's citizens.

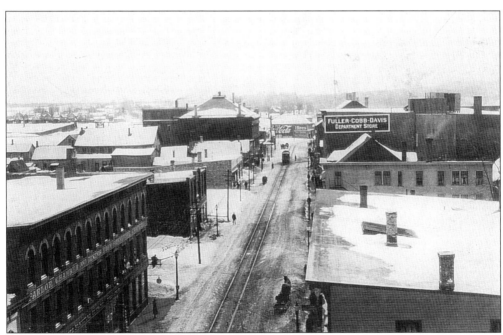

At the Syndicate Building, Mr. Davis presided over the furs and ready-to-wear department and eventually became a partner in the now Fuller-Cobb-Davis Department Store. This view, taken from the top of the former Senter-Crane's Department Store, looks south on Main Street toward the Syndicate Building.

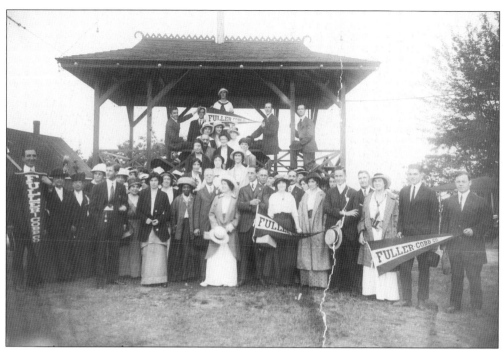

Fuller-Cobb-Davis provided an annual outing for its employees, who are pictured here at Oakland Park in Rockport.

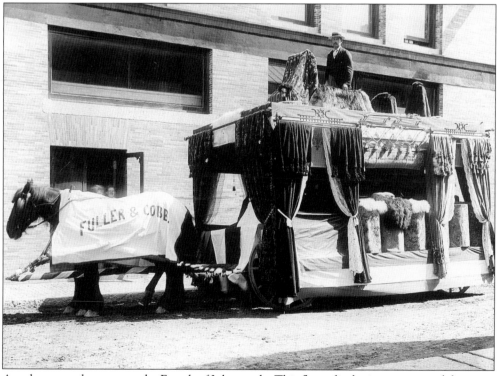

Another annual event was the Fourth of July parade. This float, displaying carpets and draperies sold by the firm, participated in the 1894 parade.

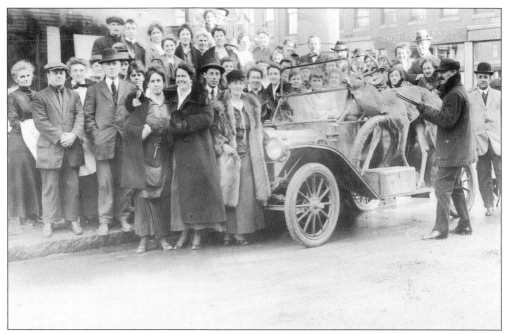

Aside from his long business experience, Ernest Davis was a sportsman. Here, holding his rifle, he has just returned from hunting on November 22, 1915, and is showing off his trophy to store employees.

Mr. and Mrs. Davis wearing furs of the type that he sold for so many years at Fuller-Cobb-Davis. Besides his work for the department store, Mr. Davis also sold antiques, invented a cleaning solution, and bred hunting dogs. After a long successful business career, Mr. Davis died on February 23, 1943.

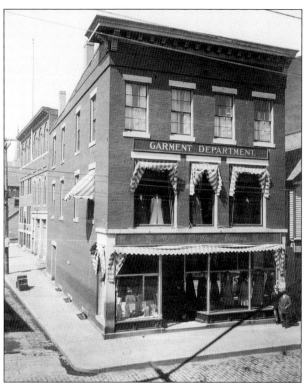

This beautiful business block housed the William O. Hewitt and Company Department Store from the 1880s until 1911, when the business moved up Main Street and evolved into the Senter-Crane Department Store.

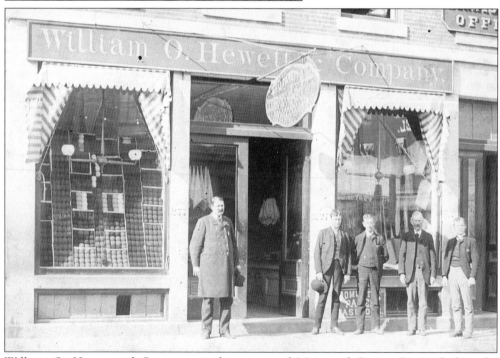

William O. Hewitt and Company at the corner of Main and Spring Streets before the building's facade was renovated. The gentleman standing by the doorway has been identified as Mr. Hewitt.

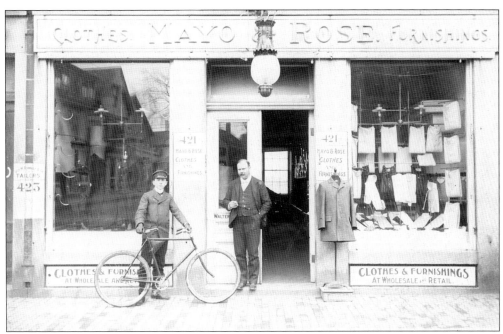

Mayo & Rose Clothiers and Gents Furnishings was located at 421 Main Street in the 1890s.

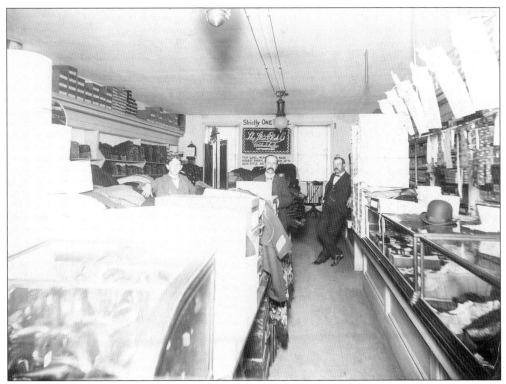

This 1896 interior shows the type of clothes and furnishings carried in clothing stores of the period.

Two well-known businesses were located at the corner of Main and Myrtle Streets: a store run by Elmer E. Simmons, and Flint Brothers' Bakery, which was owned by George A. and Frank C. Flint.

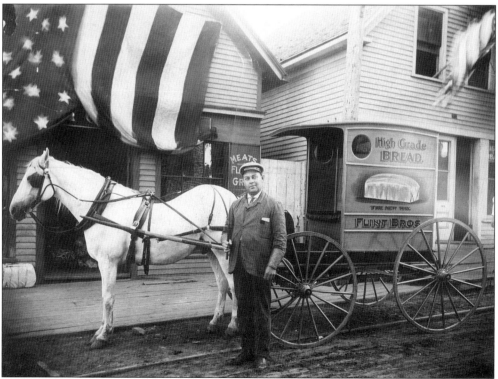

A Flint Brothers' Bakery delivery wagon with its advertising slogan.

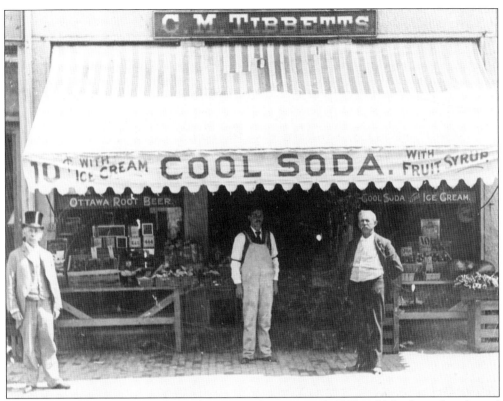

The C.M. Tibbetts Fruit and Confectionary Store around 1900 sold both cool soda and ice cream. Research reveals that this store and the one below belonged to two different Tibbetts families.

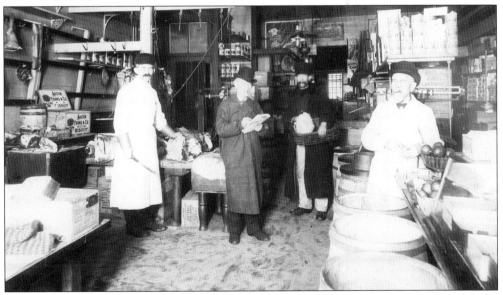

Tibbetts Market at 434 Main Street was owned by Henry Tibbetts, in the dark frock and derby. Will C. French is at the meat bench and William S. "Fat" Colson is the delivery man holding the basket. The clerk on the right is Charles Perkins. Note the sawdust covering the floor.

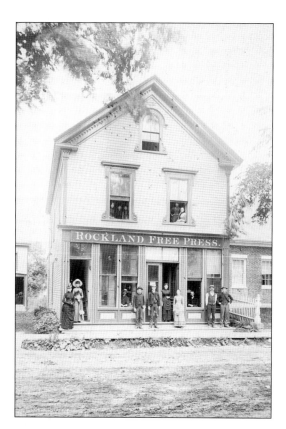

The two photographs on this page illustrate how businesses shifted in and out of well-situated buildings. In 1889, 35 Limerock Street was home to the Rockland Free Press.

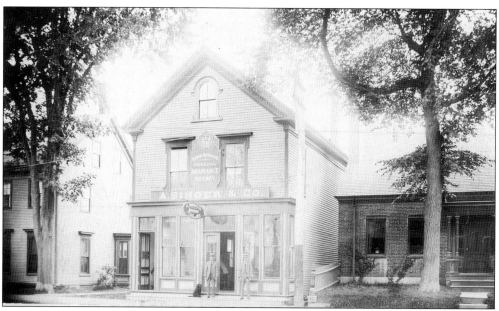

By 1897, only eight years later, there is no sign of the Free Press and 35 Limerock Street is inhabited by A. Singer and Company Tailors with Edwin Sprague's Insurance office on the second floor.

Berry's Block, with the white plaque in the middle of this picture, looks much the same today as it does in this 1870s photograph.

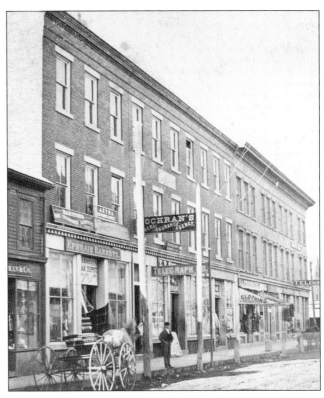

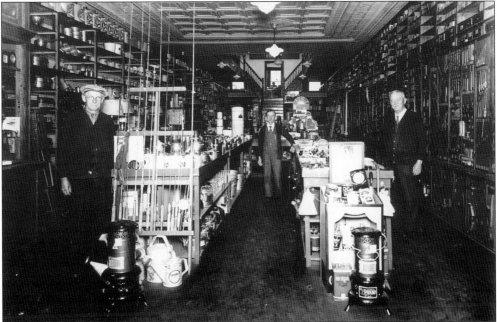

This 1920s photograph of the interior of Berry's Block at 408 Main Street shows the employees of Crie's Hardware: Lendon Jackson, Bert Maxcy, and Harry French. Mildred Waldron can be seen beyond the door in the second-floor office. The stairway in the back of this store looks just the same now as it did in the early 1920s.

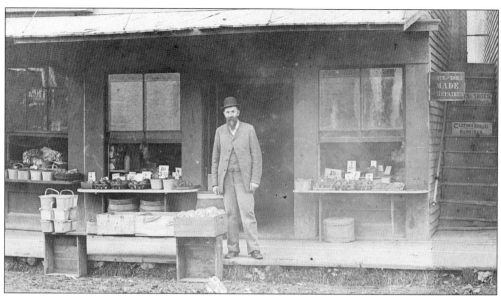

Nathan A. Packard opened his first grocery, fruit, and confectionary store shortly after the Civil War. This photograph, from the 1880s, shows how local businesses depended on sidewalk displays to help their trade.

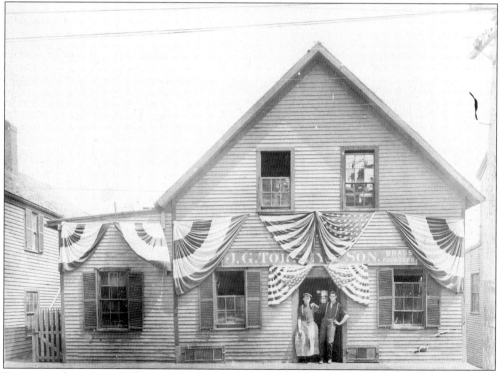

Downtown has always held more than just retail businesses. J.G. Torrey & Son Brass Founders was located at 491–497 Main Street. This company manufactured ship fastenings and marine hardware, and was widely known for the quality of its work.

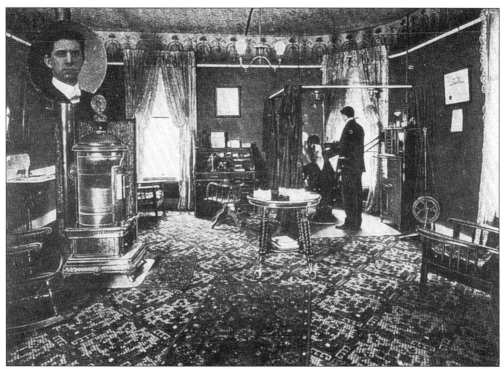

The dental parlor of J.A. Richan was typical of the professional offices that once occupied second-floor space in most Main Street blocks. With its cozy stove and foot-operated drill, a visit to the dentist was surely a memorable experience then.

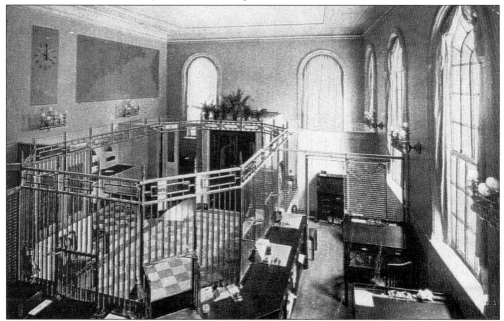

The Security Trust building, across the street from Dr. Richan, was erected in the early 1900s where Hewitt's department store had previously been (see p. 38). Interior views of offices and banks in the early 1900s are quite rare.

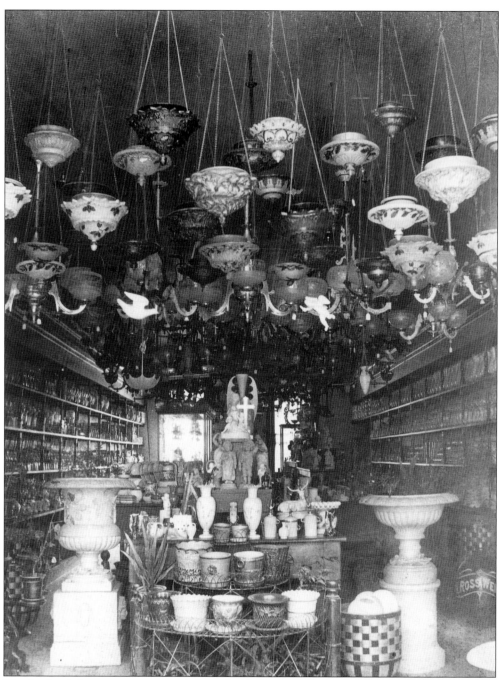

The back of this stereoscopic card from the 1880s reads: "An interior view of the store of A. Ross Weeks wholesale and retail dealer in china, crockery and glassware, silver-plated ware, table cutlery, chandeliers, fancy vases, toilet sets, smokers sets, busts and statuettes in Parian, terra cotta and bronze. Antique ware, Majolica ware, flower pots and lawn vases of every description, decorated chamber sets a specialty. Number 250 Main Street, Rockland, Maine. Photographed by F.H. Crockett, Free Press Printing." Everything described in this caption appears to be right here in the picture.

Three

City, County, and Country Government

ASSESSORS FOR 1893: A. U. BROWN, C. L. ALLEN, K. C. RANKIN.

CITY OF ROCKLAND.

COLLECTOR'S OFFICE.

M*Charles F Oxton*

The amount of your City, County and State Tax

n bills for the financial year 1893, committed to me by the Assessors of the City

Rockland, is3......... *dollars and* *cents.*

☞ READ THIS ☜

By vote of the City Council, Taxes for the present year are due and payable on the 10th day of August, and in
st will be charged from October 15th on all Taxes remaining unpaid, at the rate of 8 per cent. until February 1, 18
fter February 1, 1894, 10 per cent. interest will be charged on all taxes remaining unpaid.

RATE OF TAXATION $21.00 ON $1,000.

☞ All taxes to be paid at the office of the Collector. Collector's Office, 423 Main Street, over Crockett & Lo
y's Store.

OFFICE HOURS:—9 to 12 A. M., 1 to 3 and 7 to 8 P. M.

E. S. FARWELL, COLLECTOR.

A city of Rockland tax bill for 1893. Rockland became a city in 1854 and the county seat of the newly-organized Knox County in 1860. Additionally, the federal government has always maintained a strong presence of offices and facilities in the city.

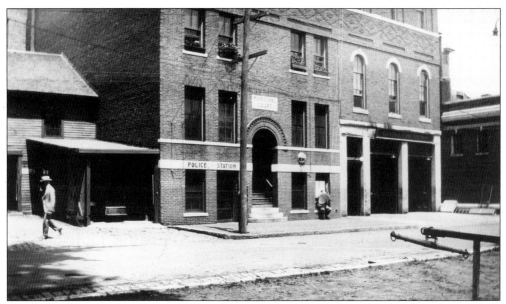

Rockland City Hall at 1 Spring Street, now Museum Street, was constructed in the late 1860s. Over the years, it contained the city marshal's office, a central fire station, the city lock-up, the municipal court, the mayor's office, city council chambers, and space for other city officials.

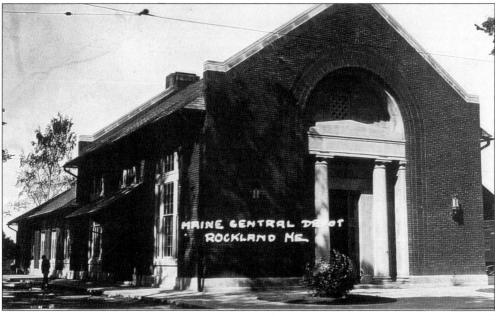

The Maine Central Railroad station at 4 Union Street became Rockland's second city hall in July 1959. Shortly afterward, the Spring Street building was demolished to create a new municipal parking lot. This former railroad depot remained city hall for more than thirty-five years. In 1995, the city council announced plans to move from this site to a new office building on upper Pleasant Street.

Three odd-numbered policemen from the turn of the century: John Brewster (right), Joseph H. Clough (bottom left), and Frank Sherer (bottom right) held numbers one, three, and five in the Rockland Police Department.

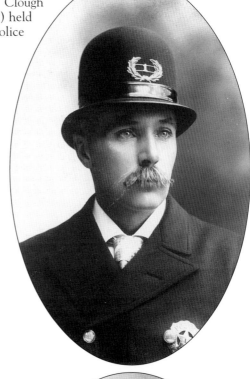

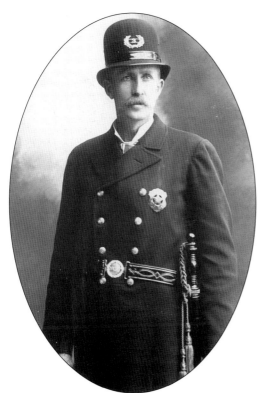

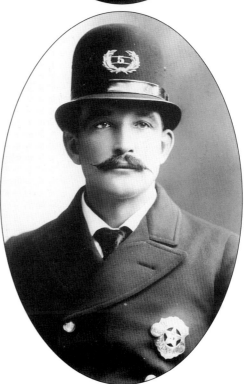

The old Spring Street armory was located on the second floor of the above building. Beyond the door to the left was the headquarters of the Americus Hook and Ladder Company, while the right part of the ground floor was the City Liquor Agency. The adjoining building on the right held the city stables and storage for the police patrol wagon.

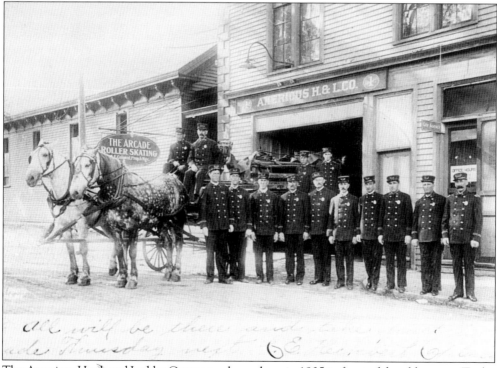

The Americus Hook and Ladder Company, shown here in 1905 in front of the old armory. To the left is the Arcade, a large one-story building used for food fairs and other community events.

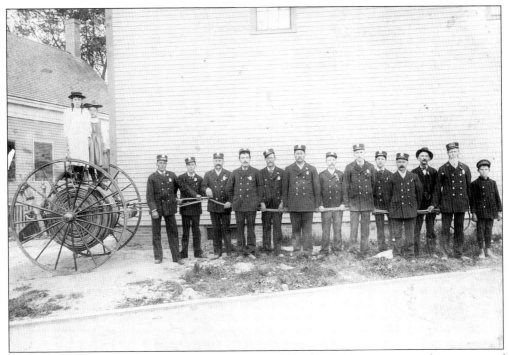

The General Berry Hose Reel was housed in one of the district fire stations at the junction of Main and Water Streets.

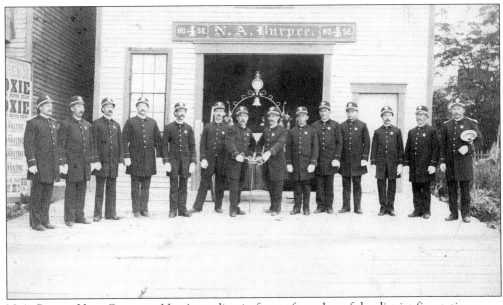

N.A. Burpee Hose Company No. 4 standing in front of another of the district fire stations.

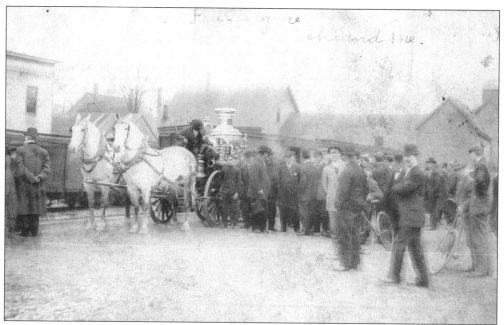

Rockland's new steam-powered pumper being delivered at the railroad freight yard.

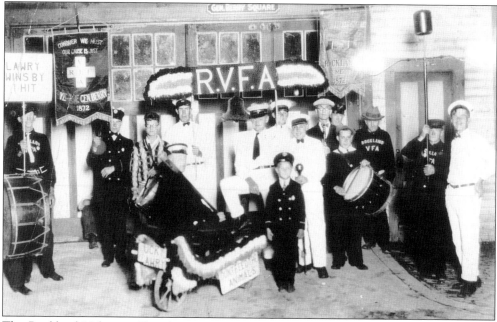

The Rockland Volunteer Fire Association after a baseball game in 1927. President George Simmons had to wheel Secretary Charles Lowry to the Rankin Block and back. Pearl Niles is holding the R.F.V.A. banner, Kenneth Moran holds the drum major's baton, Mr. Robinson is the drummer, Ralph Davis has on a soft felt hat, Lewis Hastings holds the lamp, and Van Russell is at the extreme right in the white uniform. Mr. Russell later became the fire chief and served for many years.

The Poor Farm (center), originally the Isaiah Tolman Homestead, was bought by the city in 1850 and until 1959 it was used to board citizens who could not afford other housing. It was burned by the city in 1960. To its immediate right is a small cemetery for paupers where the city set a monument in 1995. The building at the top of the picture is Rockland's Pest House, an early type of isolation ward for people with communicable diseases.

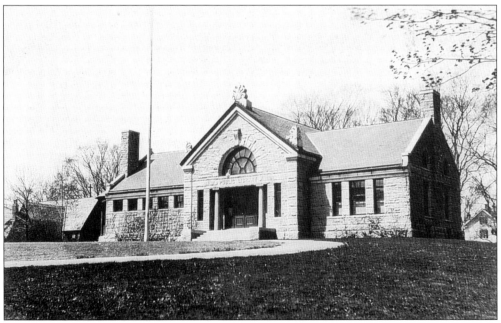

Another important city building is the public library, built on Union Street in 1903 at a cost of $30,000, with $20,000 provided by a grant from Andrew Carnegie.

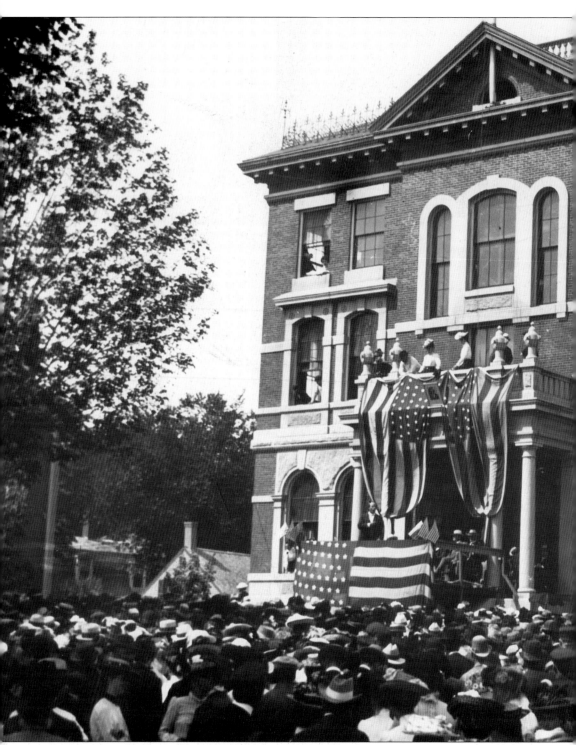

William Jennings Bryan obtained the Democratic nomination for President in 1908, but lost the race to Republican William Howard Taft. Bryan is shown here at the Knox County Courthouse while campaigning in 1908. This imposing courthouse was completed in 1875. Before that date,

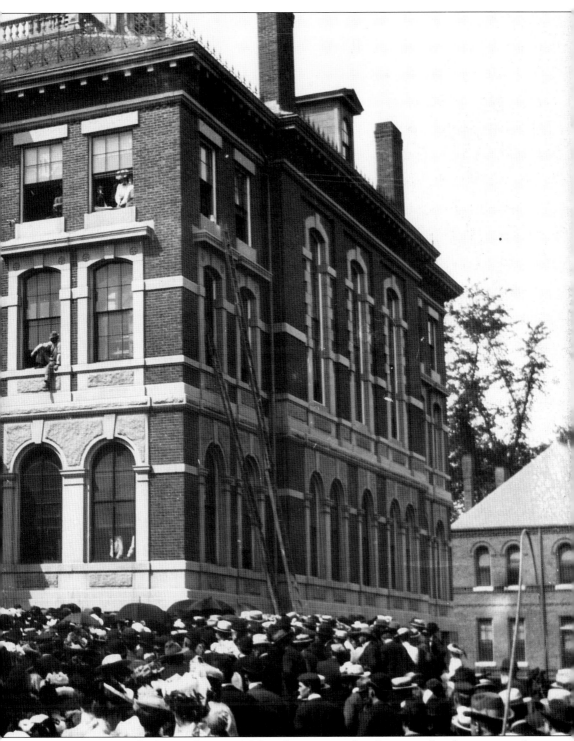

courts and county offices rented space on Main Street to conduct business after the creation of Knox County out of part of Lincoln County in 1860.

The residence of the Knox County Sheriff, with the jail in the background. Prisoners were housed in this facility from December of 1892 until 1992, when a new jail opened on upper Park Street.

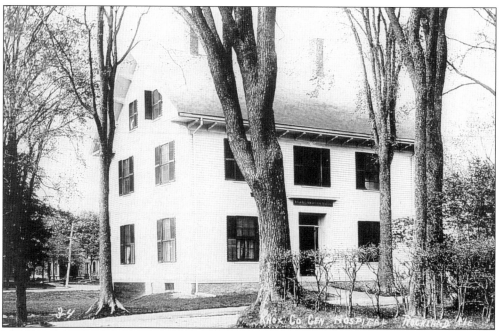

The Fessenden residence on Maple Street, after it was converted to the Knox County General Hospital in 1903.

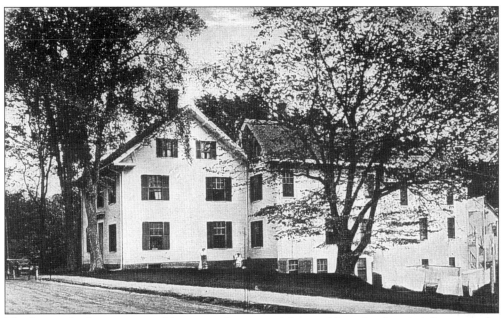

The hospital after a major addition to the original house. Note the hospital linen on the clothesline.

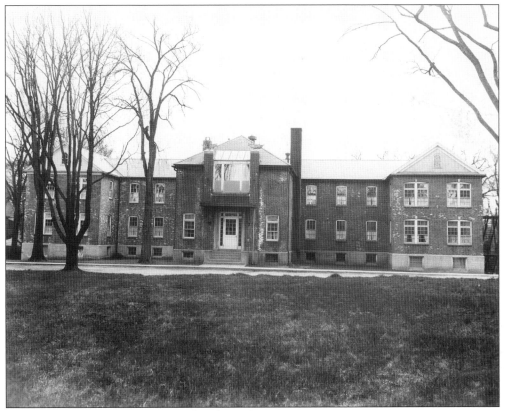

The Knox County General Hospital in the 1950s.

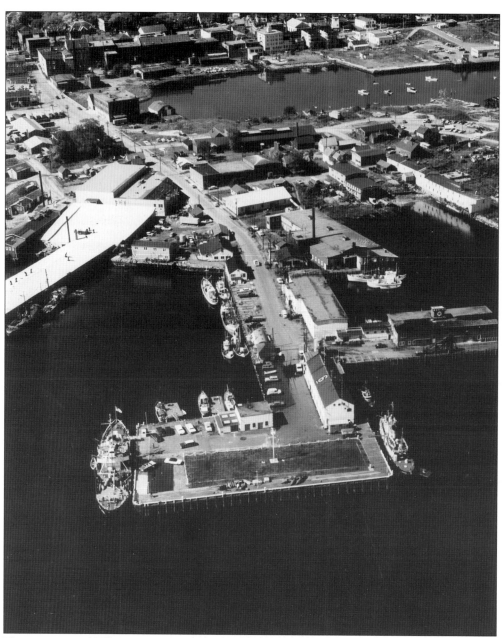

This is a view of Tillson Avenue, with the U.S. Coast Guard base at the ocean end. The top of the picture shows Lermond's Cove, which was partly filled in to allow the creation of a wastewater treatment plant in the 1970s. The coast guard base is on the site of the former Eastern Steamship Company Wharf. Tillson Avenue was also the site of the East Coast Fisheries after World War I. The long shed at the left is the former Forty Fathoms fish plant. At the top, just below Lermond's Cove, is the Bicknell Manufacturing Company (formerly Livingston Manufacturing), which makes quarrying tools. Immediately to the left of Lermond's Cove is the Bird Block, built in 1898 as the home of the John Bird Company, which dealt in spice and was famous for its Three Crow Brand products. Since the 1980s this building has been the local coast guard headquarters.

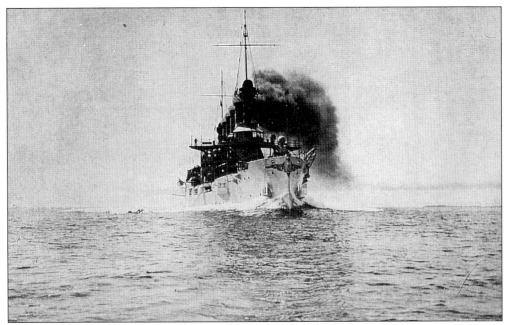

The U.S.S. *Montana* is shown here in 1908 reaching her top speed of 22 knots on the measured mile trial course off Owls Head. This trial course was used for decades by U.S. Navy and civilian ships to see if they were as fast as their builders had guaranteed. The course is still marked on current navigational charts.

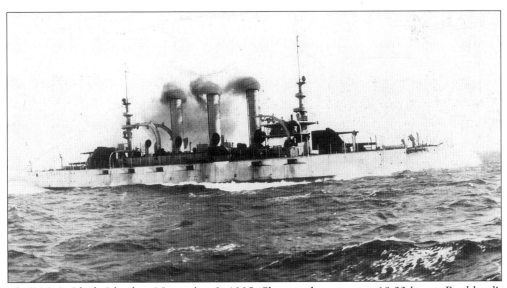

The U.S.S. *Rhode Island* on November 2, 1905. She ran the course at 19.33 knots. Rockland's trial course consists of range markers on Monroe Island, Sheep Island, and in Owls Head that indicate a measured mile.

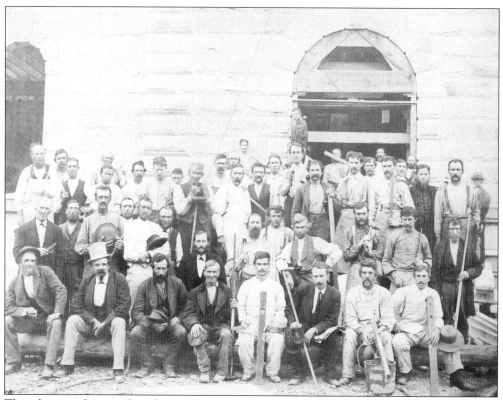

This photograph was taken during the construction of Rockland's granite customs house and post office, completed in 1876. Many of the nearly fifty workers shown here are holding tools or implements used in their trade.

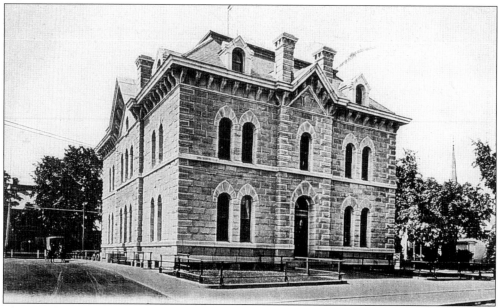

The completed post office was a landmark building in the city for many years. This view shows how it looked before the addition in 1935 to accommodate postal service vehicles.

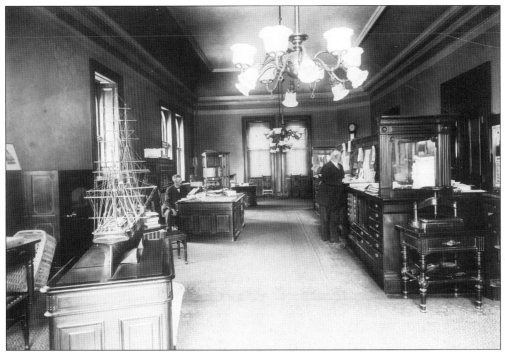

The U.S. Customs office on the second floor of the post office in July 1914. Working at the desk is Herbert W. Thorndike, while Charles Magee stands at the counter. This photograph was copied in 1968 and placed in the cornerstone of Rockland's new federal building on Limerock Street.

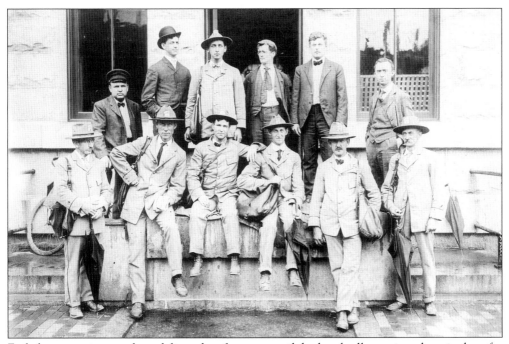

Early letter carriers, ready to deliver the afternoon mail, had umbrellas against the rain, hats for the heat, and bicycles for speed. At that time, mail was delivered twice a day.

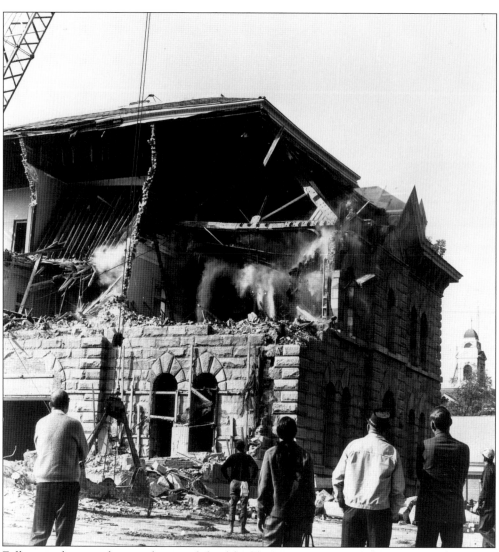

Following the completion of a new federal building across Limerock Street, the old customs house and post office was sold and then demolished. Quoting from the *Courier-Gazette* article of September 25, 1969: "Many a citizen of Rockland has paused since Tuesday morning on School Street or Limerock Street and made a sad comment on the razing of the old post office." On October 4, 1969, the paper reported: "It took heavy equipment and more than a little know-how by George Hall's crew to lower the roof on the old Rockland post office Thursday. Most of the day found a crowd of from a dozen to 50 spectators on hand and some were rewarded by thundering crashes and clouds of dust."

Four

Celebrations and Conflagrations

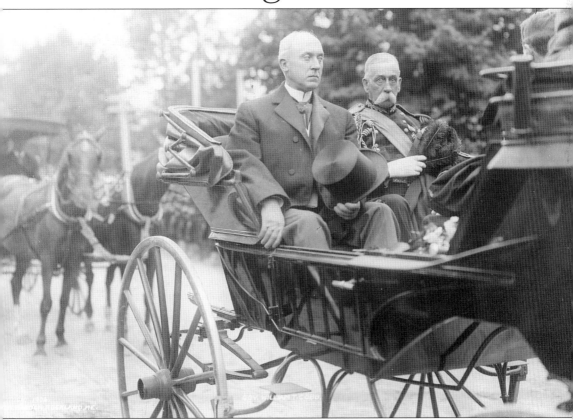

Throughout Rockland's history, the two things most guaranteed to draw a crowd have been a parade or a fire. William T. Cobb, the famous local entrepreneur and the only governor of Maine to ever hail from Rockland, is shown here riding up Main Street in an open carriage.

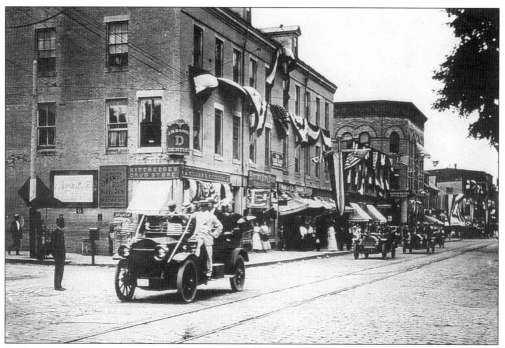

Perhaps the most anticipated celebration in small-town America has always been a Presidential visit. In July 1910 President William Howard Taft came to Rockland. His motorcade is shown here at the corner of Main and Park Streets.

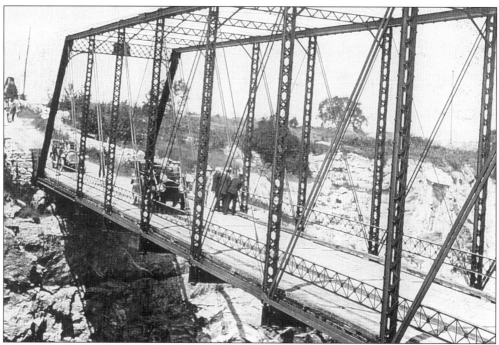

While in Rockland, President Taft stopped on a bridge to view the deepest lime quarry in the world.

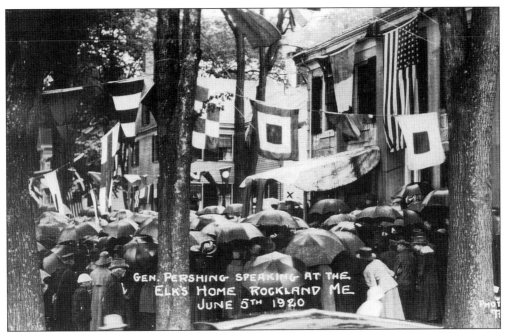

A crowd gathers to hear General Pershing speak in June 1920 outside the Rockland Elks Lodge at the corner of Main and Granite Streets.

These sailors were photographed in front of the post office, probably before World War I. It is not known whether they were stationed here or from a visiting ship.

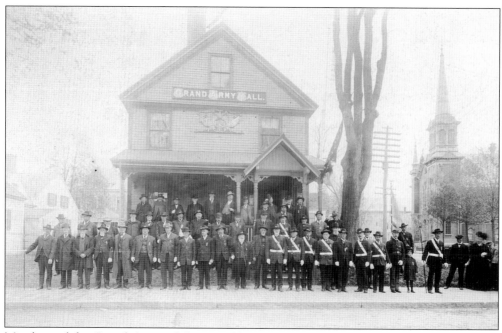

Members of the Grand Army of the Republic outside their hall on the corner of Limerock and Union Streets in the 1880s. The carved eagle on the front of the building was originally attached to the U.S. Customs House when it was located on Main Street. Rockland, whose sons showed the highest patriotism and bravery as members of "The Iron Fourth" during the Civil War, maintained one of the most active G.A.R. posts in New England.

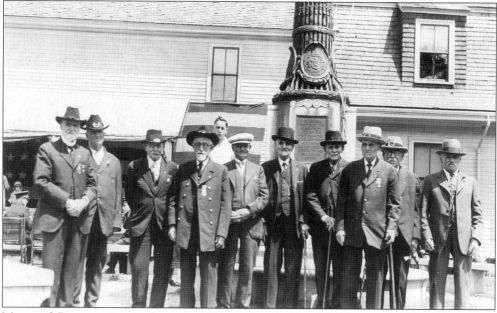

Memorial Day exercises in the early 1930s at the Rockland Soldiers and Sailors Monument beside the G.A.R. Hall. Shown here are Rockland's last surviving Civil War veterans. From left to right are: William Huntley, Benjamin Davis, Samuel Rankin, F.S. Philbrick, Allen Kelly, George Cross, William Benner, Henry Huntley, William Maxcy, and Eugene Ryder.

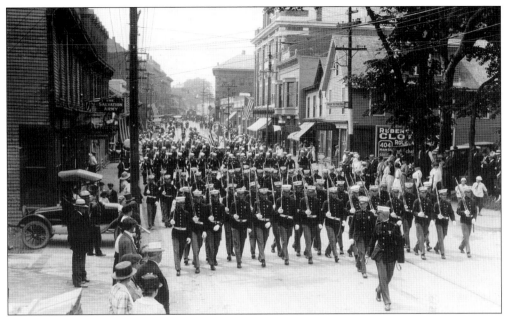

The holiday celebrated for the longest time in Rockland has been the Fourth of July. This Independence Day parade is marching up Main just past Lindsey Street.

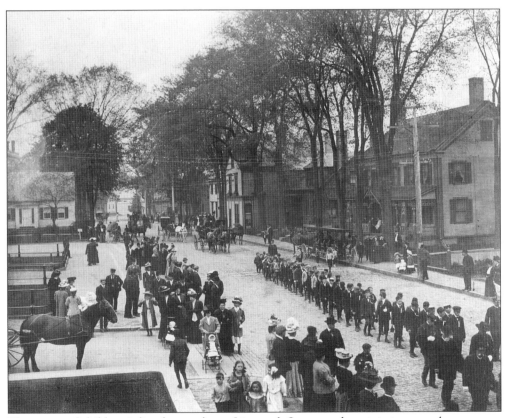

This group of children is lined up on lower Limerock Street ready to join in a parade.

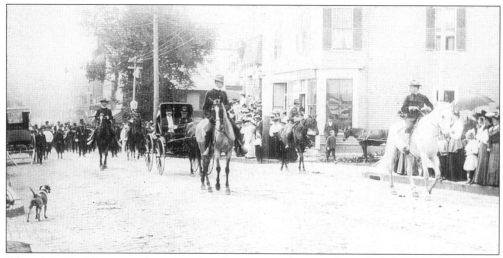

Edward K. Gould, mounted on the white horse, served as grand marshal for one of Rockland's Old Home Week parades, shown here passing Summer Street.

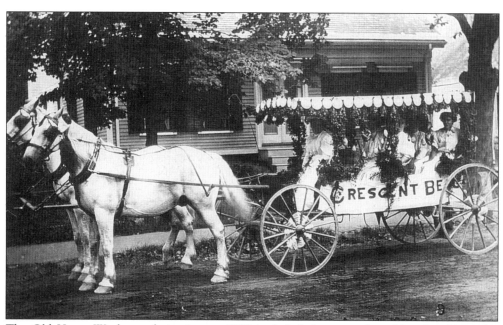

The Old Home Week parade in August 1908 included this entry from Mrs. Smith's at the Crescent Beach Inn.

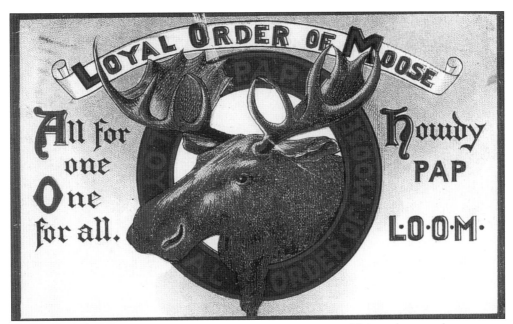

Many fraternal organizations were once active in our community. This card was used to summon members of the Loyal Order of Moose #457 to a meeting and supper on Park Street.

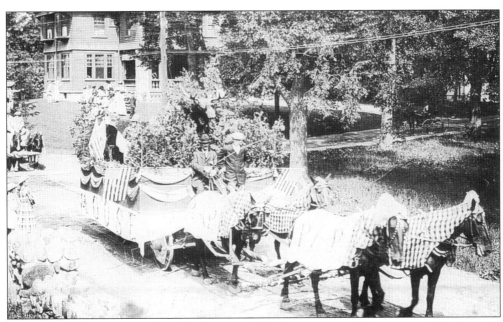

A float being driven across Lincoln Street in 1910 shows many of the same symbols from the Loyal Order of Moose that can be seen on the card at the top of the page.

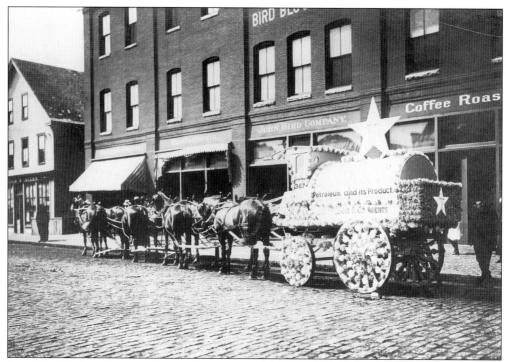

Local fuel dealers from the Texaco Company maintained a presence in Rockland's parades for many years. This horse-drawn float is stopped in front of the Bird Block on Sea Street, now Tillson Avenue, in 1912.

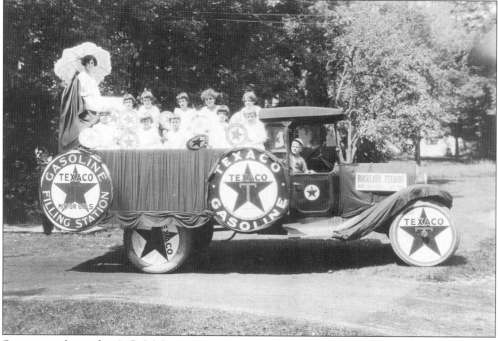

Some years later, the A.C. McLoon Company provided this truck displaying the same Texaco Star, but filled with local beauties.

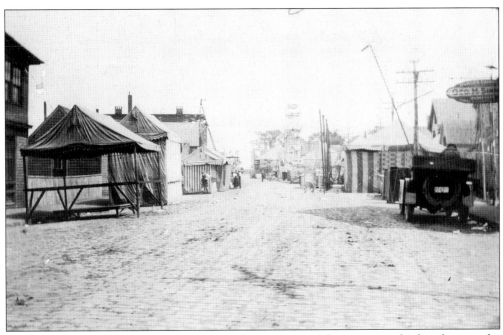

The custom of exhibits and entertainments during local celebrations goes back at least to the turn of the century. This picture is a rare view of a midway on Tillson Avenue between Main Street and the Bird Block.

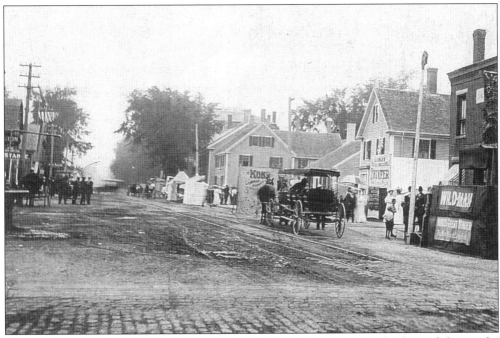

These displays on Park Street were for the Old Home Week in 1908. The first exhibit on the right is where you paid your penny and went to see the wild man.

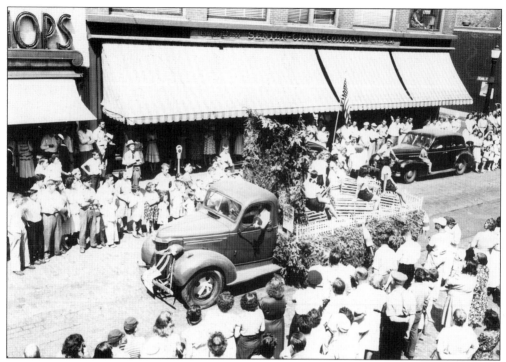

Since 1948 Rockland has had a festival uniquely its own called, at various times, the Maine Seafoods Festival or the Maine Lobster Festival. Pictured here is a portion of the first festival parade on July 31, 1948.

Lobster Festival parades have always attracted huge crowds and many street vendors. Here the camera catches a vicious balloon attack at the corner of Granite and Main Streets.

Two "sea princesses" from the early 1950s in a publicity photo used in press packets given to newspapers outside the Rockland area to promote our Lobster Festival.

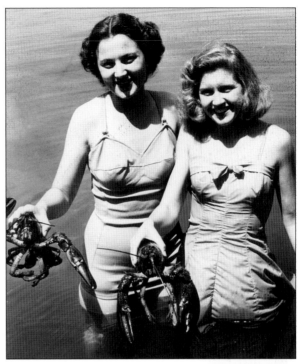

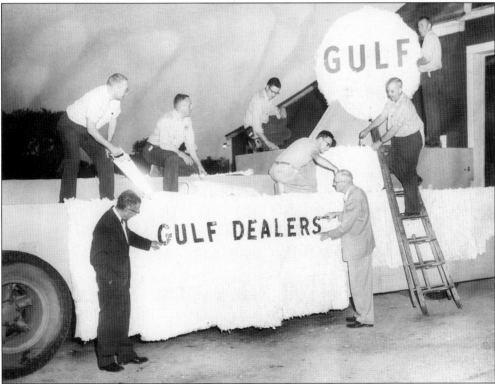

Ellery T. Nelson, to the left of the ladder, and employees from his Gulf dealership finish work on a parade float to carry the Lobster Festival Sea Goddess and King Neptune.

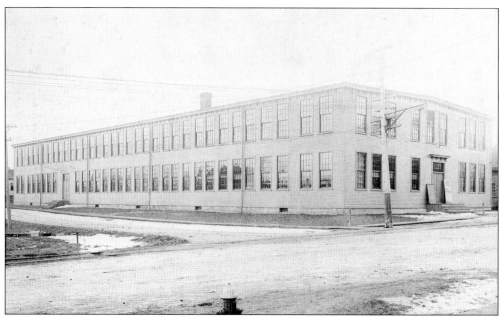

Many local people mark the passage of time partly through the dates of early fires. One of our earliest notable fires of this century was in 1907 at the Mowry & Payson Pants Factory on Park Street.

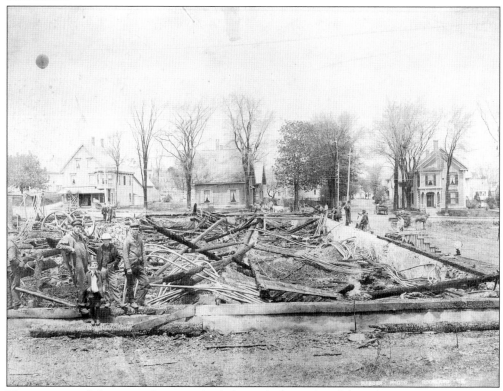

The remains of the pants factory, which burned on Wednesday night, June 5, 1907. This photograph shows that even the ruins after a fire captivated the curious.

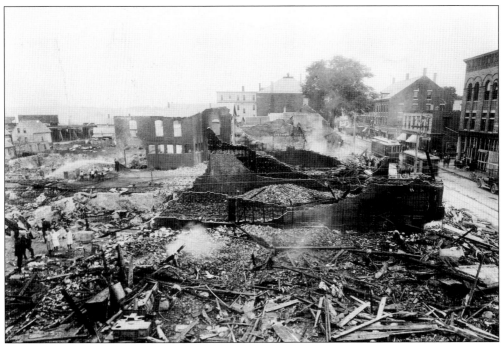

Rockland's entry into the Roaring Twenties came with the Berry Brothers' Stable fire on June 16, 1920. This fire devastated a large section of the east side of Main Street. The heat was so intense that it damaged the windows of Fuller-Cobb-Davis Department Store across the street.

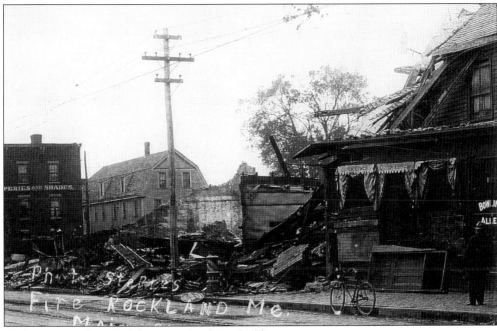

A closer view of ruins of the Berry Brothers' Stable.

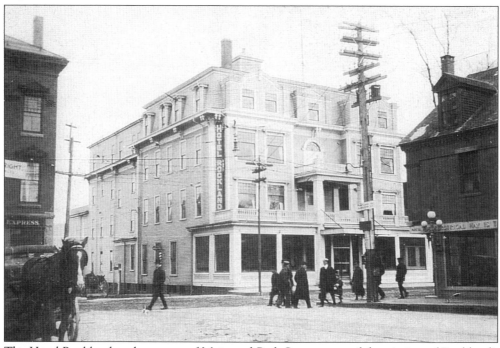

The Hotel Rockland at the corner of Main and Park Streets, one of the victims of Rockland's million-dollar fire on the night of Friday, December 12, 1952.

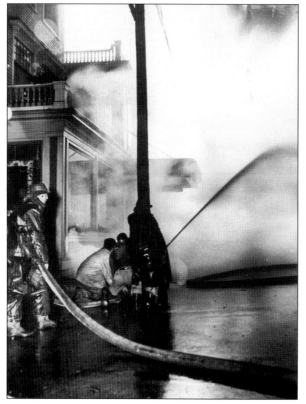

A view showing the Hotel Rockland's porch engulfed in flames as the fire moved from the Studley Furniture Company through the hotel.

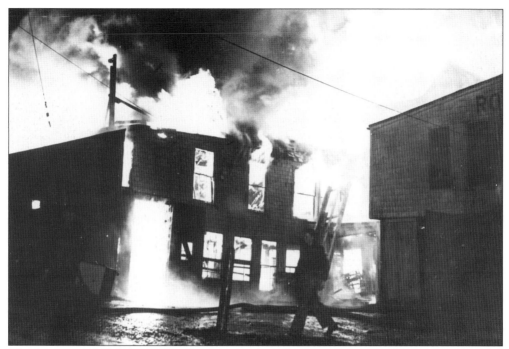

The disastrous 1952 fire at its height. Quoting from the *Courier-Gazette* of December 13, 1952: "Fire trucks screamed over highways from the Kennebec to the Penobscot Rivers last night racing to Rockland to fight what proved to be a million dollar blaze. Thirteen departments from Brunswick to Bangor sent apparatus in answer to calls from Chief Van E. Russell who quickly recognized that he was faced with a conflagration which might engulf the city if it got away."

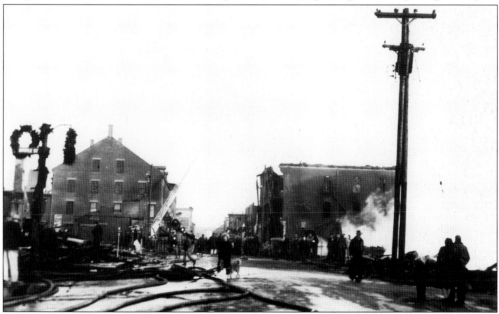

The morning after Rockland's worst fire. A total of twenty-two businesses or private dwellings were destroyed on portions of Park and Main Streets south as far as Myrtle Street. The total loss was set at $1.5 million and it took several years to rebuild that part of our downtown.

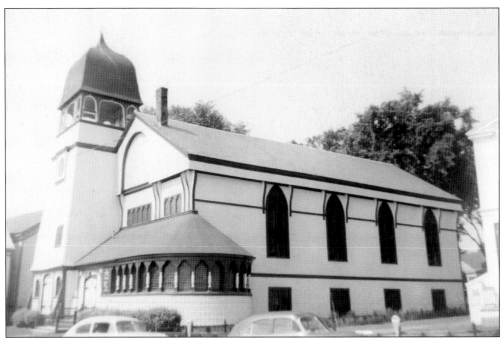

The Rockland Congregational Church, located on Main Street from 1838 to 1971.

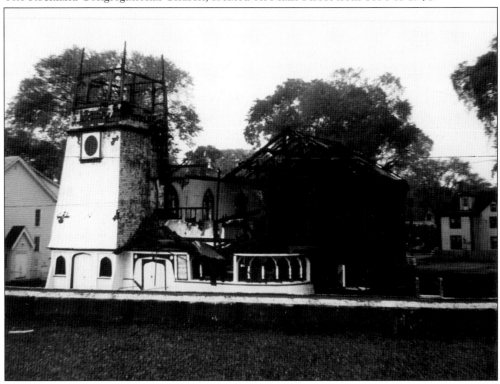

By the fall of 1965, Rockland's Congregationalists had built a new church on Limerock Street and had sold this Main Street structure. On the night of October 9, 1971, fire broke out in an adjacent building, and it soon spread to and completely destroyed the old church.

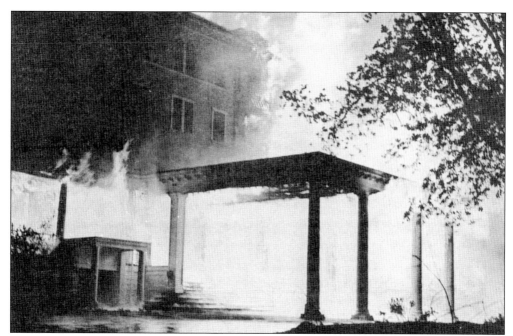

The history of local fires would seem incomplete without including the spectacular blaze that completely destroyed our ninety-three-year-old resort, the Samoset Hotel, on Friday, October 13, 1972. This picture shows the familiar front portico of the hotel just thirty minutes after firemen arrived.

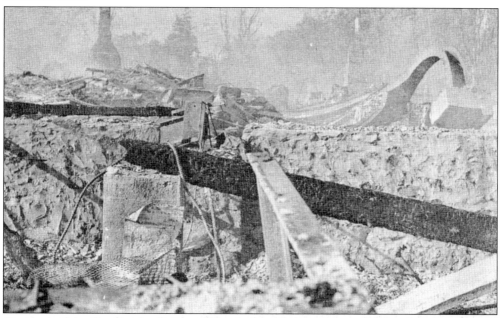

As reported in the *Courier-Gazette*: "The roaring flames generated heat that twisted steel I-beams into ribbons and caused many explosions within the confines of the building." Firefighters spent most of their time protecting surrounding property because the fate of the old Samoset was sealed as soon as the fire started. It has since been replaced by the new Samoset Resort.

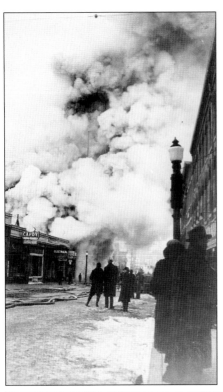

The Masonic Temple fire of 1940 (left) and the celebration near the home of Fred R. Spear on Beech Street (below) show that celebrations and conflagrations have always drawn the biggest crowds in Rockland.

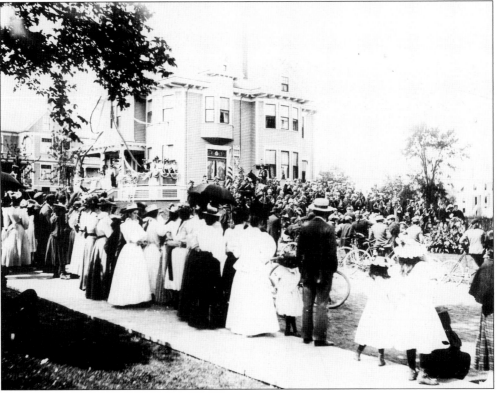

Five

Transportation, Tourism, and Telecommunications

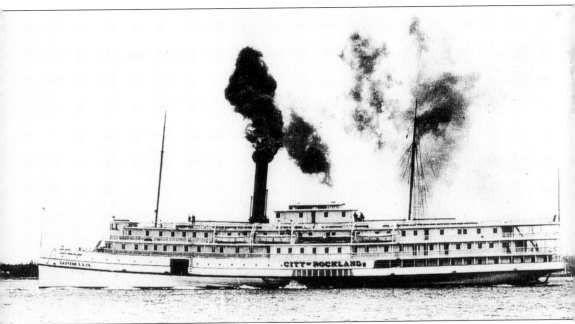

Before modern modes of transportation, people traveled to Midcoast Maine by horse, stagecoach, and ship. Rockland became a hub of transportation activity by the 1860s with the advent of regular passenger steamship service. This photograph is of the paddle wheel steamboat *City of Rockland*, launched in 1900 and acknowledged as queen of the "Boston Boats." The *City of Rockland* was 274 feet long and could carry 2,000 passengers and 600 tons of freight.

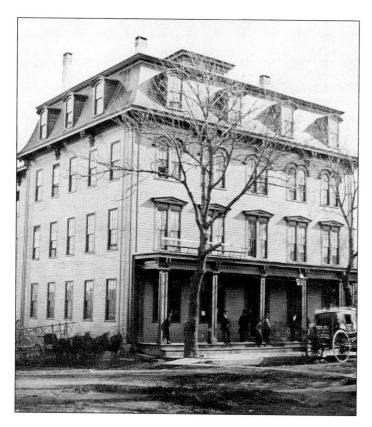

The Lynde Hotel at the corner of Main and Park Streets was opened in 1870 by George Lynde, who also ran a stagecoach service between Rockland and St. George.

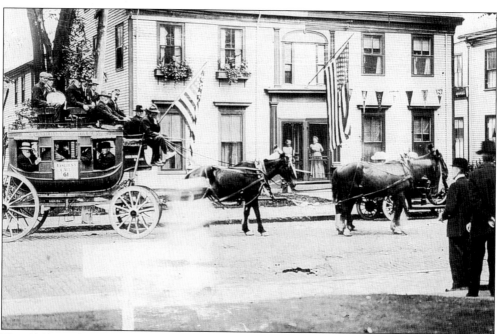

This 1910 parade on Limerock Street has local Civil War veterans riding in and on a stagecoach of the Rockland, Damariscotta and Bath Line. The sign on the coach door reads "Lincoln's Call '61."

The Lindsey House, originally built by George Lindsey as his residence in 1835, was greatly enlarged and opened as a hotel a few years later. This Lindsey Street hostelry was converted to offices for the Camden-Rockland Water Company in 1924, but was returned to its former use when opened in 1995 as the Captain Lindsey House Inn.

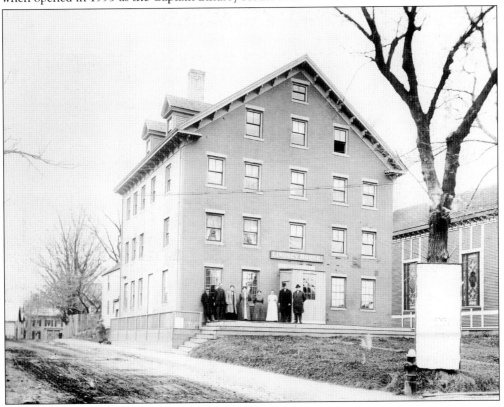

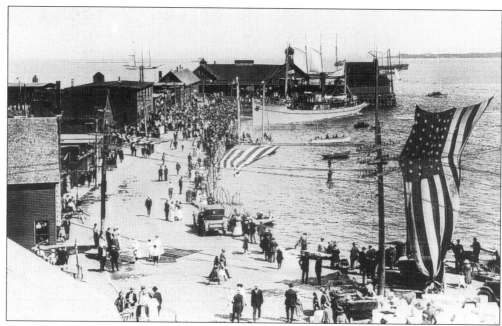

Pelican Day, 1919. This view is of the first of several steam fishing trawlers arriving at Tillson's Wharf. Its arrival was celebrated by hundreds of spectators.

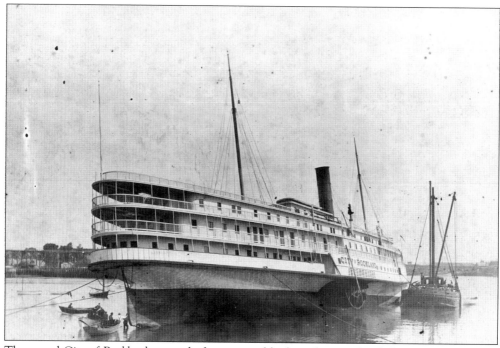

The proud *City of Rockland* was only four years old when she struck a ledge near Ash Island, south of Rockland. Her 400 passengers were rescued, and she was raised by salvage ships and towed into Rockland, where she was purposely beached (as seen here) so her hull could be patched temporarily. She was then taken to Boston for repairs and served until 1923.

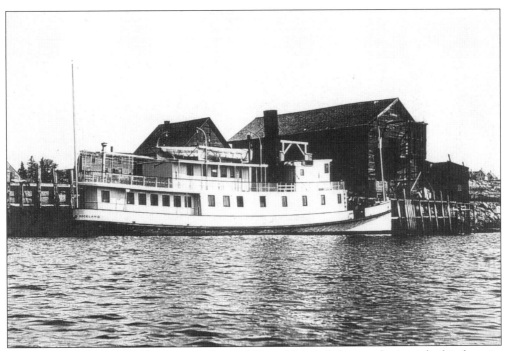

The so-called "little" *Rockland* was built in 1883 and labeled thus to distinguished it from its much larger counterpart. It carried passengers and freight to ports on the Penobscot River and Penobscot Bay. She is shown here stopping at Vinalhaven.

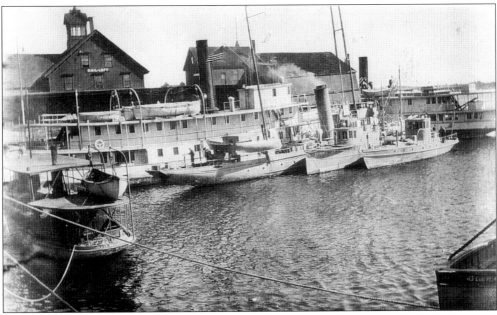

Tillson's Wharf, with numerous steamboats and other craft. Located at the end of Sea Street, now Tillson Avenue, it was the center of steamboat activity in Rockland from its opening in 1881 until it was purchased and taken over by the U.S. Coast Guard following World War II. It cost an incredible $100,000 to construct and was considered a risky business venture at the time.

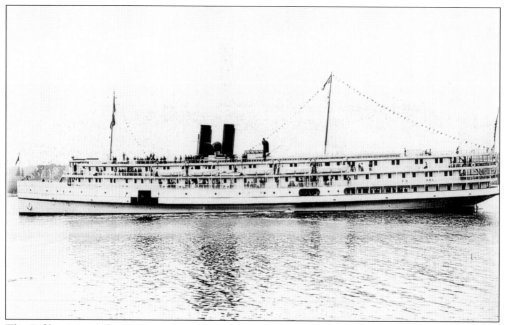

The *Belfast* joined the Eastern Steamship Company fleet on the Boston to Bangor run in 1909 and continued until 1935. Faster and more reliable than her predecessors, she and her 1907 sister ship, the *Camden*, are the most remembered of the "Boston Boats."

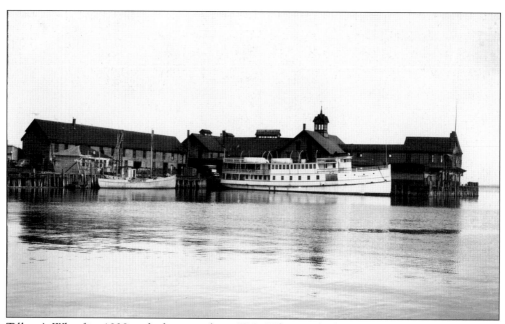

Tillson's Wharf in 1938 with the steamboat *W.S. White* ready for a run to Vinalhaven. By this time the wharf was used primarily for local island travel, with longer trips made mostly by train or automobile.

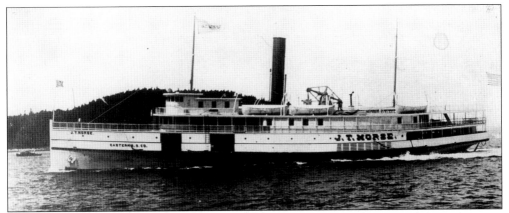

One of the best-loved local steamboats was the *J.T. Morse*, which operated for many years between Rockland and Bar Harbor as well as ports in between. Launched in 1901, she ran here until 1933, when she was sold to another shipping line and her name was changed to the *Yankee*.

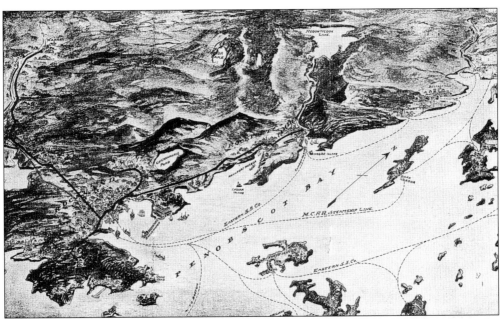

This 1915 bird's-eye view of transportation in the Rockland area is unique because it shows: the lines of travel for the Eastern Steamship Company, which ran the Boston to Bangor boats as well as other more localized steamers; the lines of the Maine Central Railroad and its steamship line; and the routes of the Rockland, Thomaston & Camden Street Railway Company's electric trolley cars.

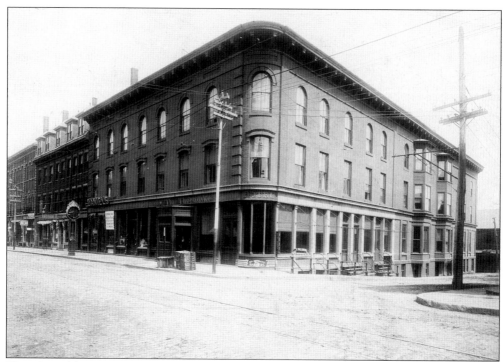

The Thorndike Hotel, located at the corner of Main Street and Tillson Avenue (formerly Sea Street), was within walking distance of Tillson's Wharf. It operated as a hotel from 1855 until the late 1970s and is now an apartment block. Because of its central downtown location, the Thorndike catered to businessmen and traveling salesmen, especially during the period from 1937 to the 1970s, when it was owned by Nathan Berliawsky.

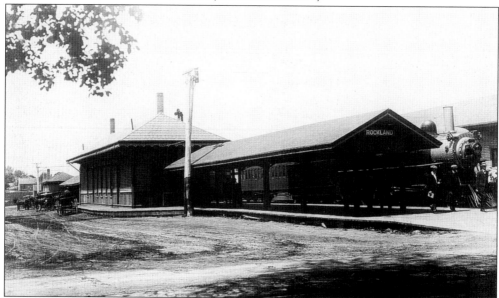

This is a pre-1917 photograph of Maine Central Railroad's passenger depot on Portland Street, near the corner of Pleasant and Union Streets. Portland Street was later discontinued and taken over by the railroad.

The Narragansett Hotel at Park and Union Streets was renamed from the Maine Central Hotel soon after it opened. Now called the Wayfarer East, it has operated continuously as a hotel since at least the 1880s. Just as the Thorndike was handy to the steamship wharf, so the Narragansett was "within half minute's walk of the railroad station."

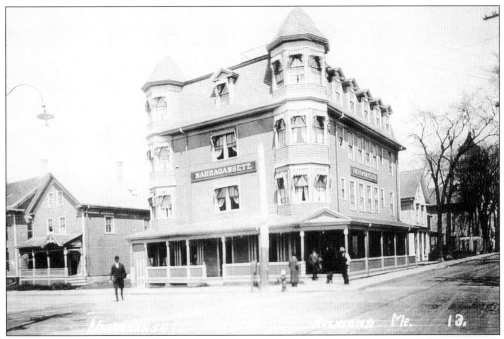

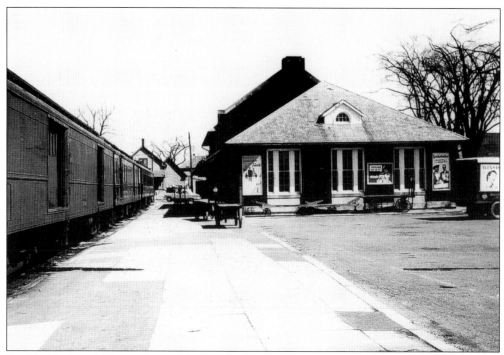

Rockland's "new" Maine Central Railroad station of 1918 is shown here in the 1940s. This view, from the west of the freight end of the station, shows a Railway Express truck and several railway cars as well as freight wagons waiting to be unloaded.

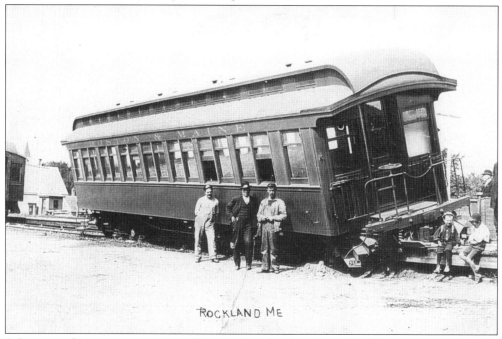

A Boston and Maine passenger car off the tracks in Rockland in 1908. While the exact location is uncertain, what appears to be the spire of St. Bernard's Catholic Church on Park Street can be seen in the left background.

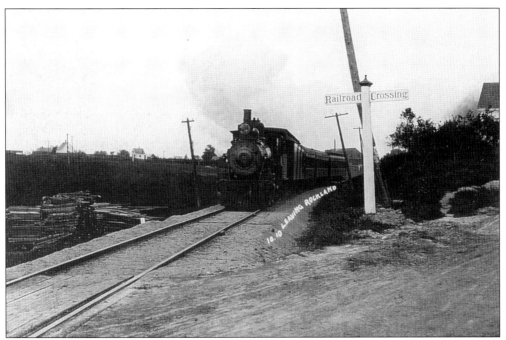

"The 10:10 Leaving Rockland." This train is approaching a crossing at the end of New County Road where it meets Pleasant Street.

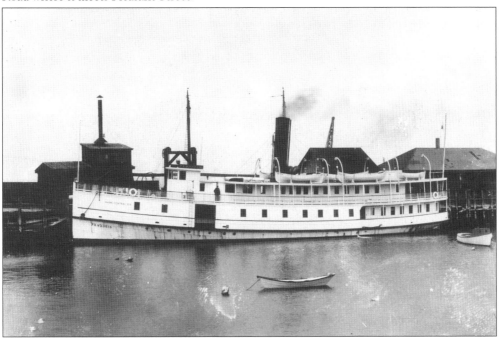

Maine Central Railroad owned the steamer *Pemaquid*, shown here at the Maine Central Railroad Wharf in Rockland's South End. This wharf provided a commercial anchorage for local steamboats owned by the railroad and allowed a continuum of travel from train to ship. Steamers like the *Pemaquid* carried passengers and freight from Rockland to Islesboro, Castine, and other eastern ports.

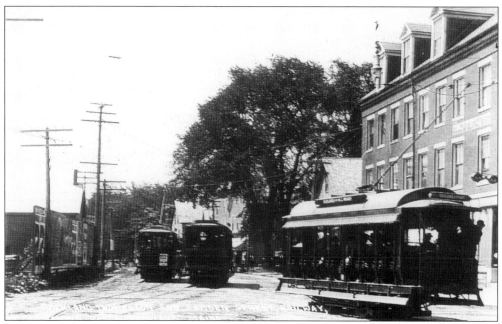

This view of street cars passing at the Rankin Block in the early 1900s is unusual because it shows three trolleys close together. The two Rockland, Thomaston & Camden Street Railway cars on the left are headed north and south; the third, closer car, proceeds from the Highlands to the Maine Central Railroad Wharf opposite the corner of Atlantic and Mechanic Streets.

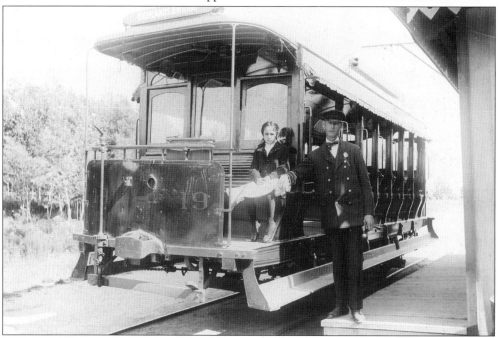

A close-up view of a summer car of the Rockland, Thomaston & Camden Street Railway also on the line from the Highlands to the Maine Central Railroad Wharf. It may be near Blackington's Corner at Maverick Street and Old County Road. This line of the street railway brought people from western parts of the city to the downtown area.

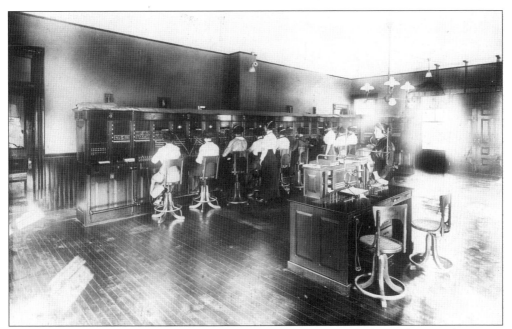

All types of commerce were made easier by the installation of telephones here in the 1880s. This 1913 photograph shows operators in the office at the corner of Union and School Streets. The chief operator standing near the desk is Mabel Hahn Colson.

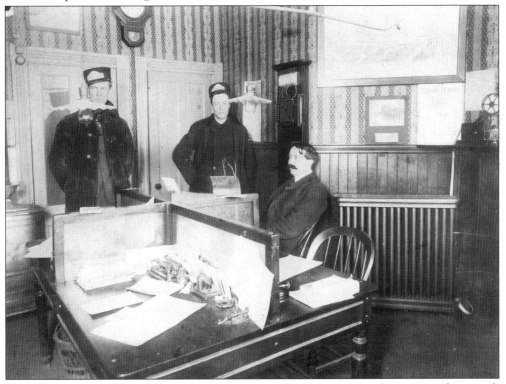

The telegraph preceded telephones and continued well into the 1900s. This interior photograph shows both operators and messengers at the Rockland Office.

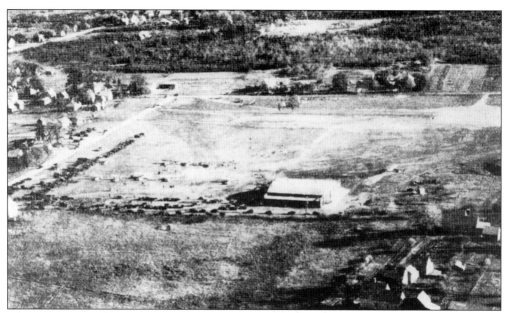

The Curtiss-Wright Airfield, located near the corner of Broadway and Thomaston Street, brought civilian aviation to Rockland. This aerial view is from a 1939 directory of U.S. airports.

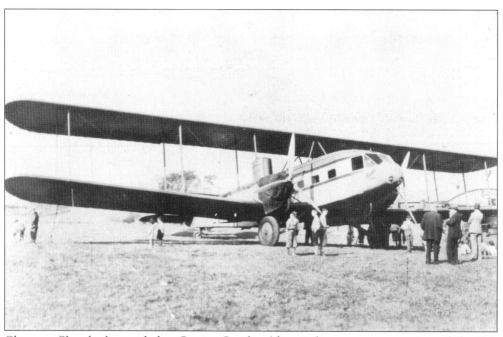

Clarence Chamberlin, with his Curtiss Condor (the civilian transport version of the B-2 bomber), visited the Curtiss-Wright Airport around 1936.

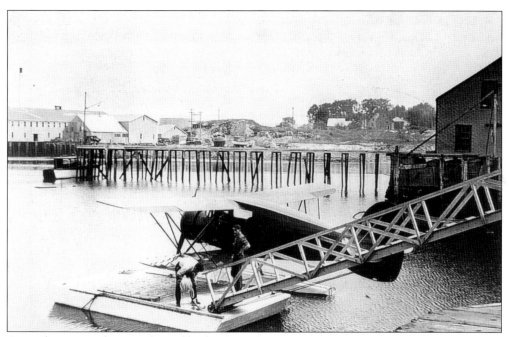

A seaplane at its base at the public landing about 1940. Seaplane service provided a faster alternative to boat travel to the islands in Penobscot Bay.

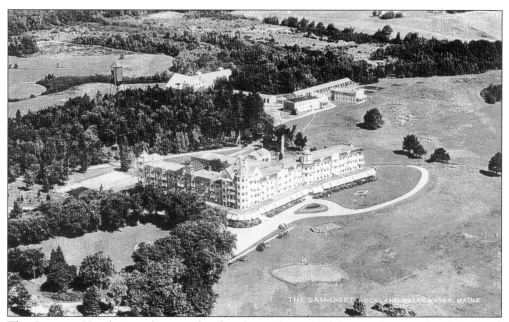

The Samoset Hotel, in a photograph taken by a Curtiss Wright aerial survey in 1924. Local residents have long enjoyed airplane rides for sightseeing purposes, and the Samoset has always been a spectacular sight.

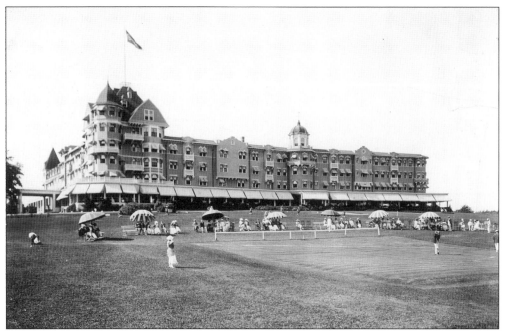

The Samoset was opened in 1889 as the Bay Point Hotel and was renamed Samoset when bought by the Ricker family in 1902. It soon expanded to two hundred rooms, and operated until 1969 as the premier resort on the coast of Maine.

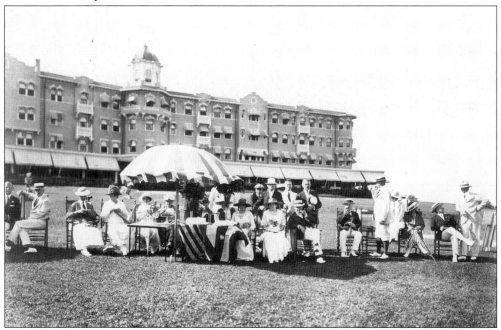

A golf gallery watches play on the course in front of the Samoset. From the 1890s to the 1960s, many visitors spent the summer season of June to September at the famous resort. The local economy also benefitted from years of convention business both before and after the season each year, and hundreds of local young people started their working careers at the Samoset Hotel.

Six

Posed for the Camera

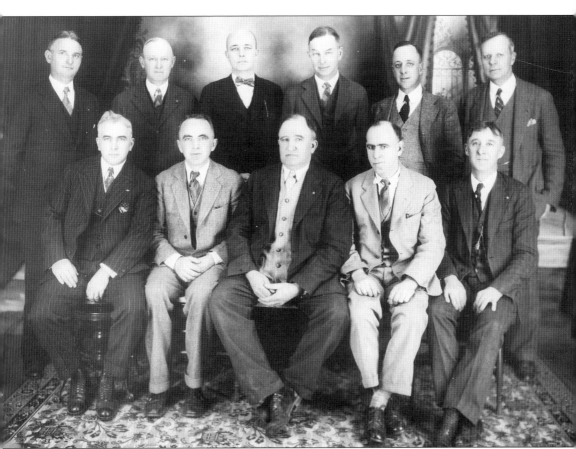

Rockland's founding Chamber of Commerce Board of Directors from 1926–27. From left to right are: (front row) Joshua Southard, Executive Secretary Charles Hewett, Willis Ayer, Elmer Crockett, and Herbert Blodgett; (back row) Henry Bird, Frank Rhodes, Kennedy Crane Sr., William Glover, Walter Ladd, and Edwin Brown.

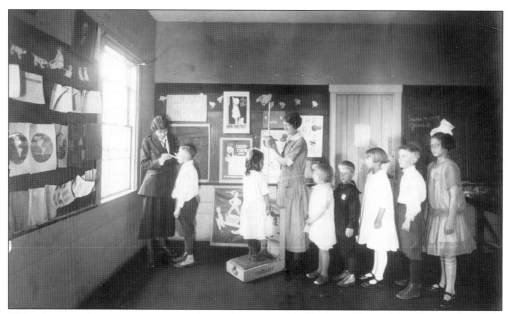

This photograph, taken on June 4, 1924, shows "health day" at the Highland School on Old County Road. It was the duty of the public health nurse to measure and weigh children and teach health pointers. This position was held by Eliza Steele from 1929 until her retirement in 1969.

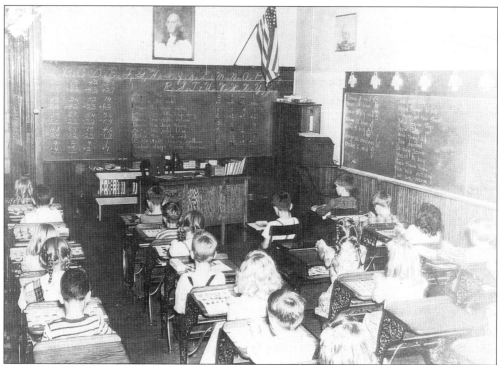

While it is certain that this elementary classroom is in a Rockland school, we could not determine which of our primary schools it was or its exact date, although it appears to be from the 1940s.

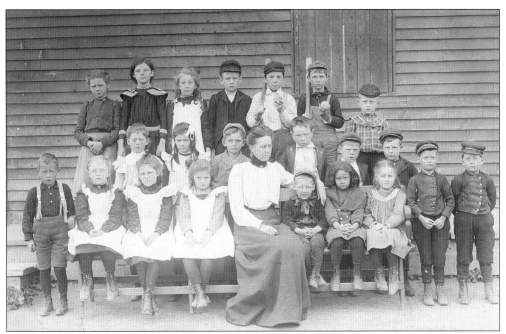

This early 1900s photograph is of a multi-grade primary school group, who look very unhappy posing for the camera.

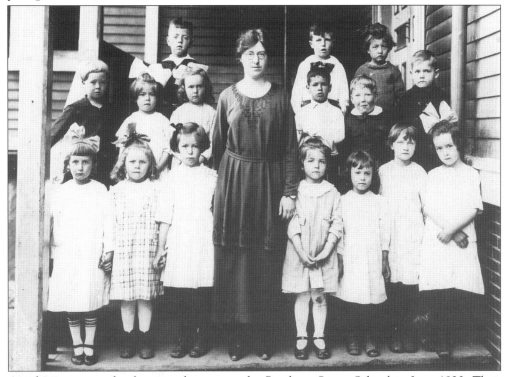

Another primary school group, this one at the Purchase Street School in June 1920. Their teacher has a much more benevolent look than the one in the photograph at the top of the page.

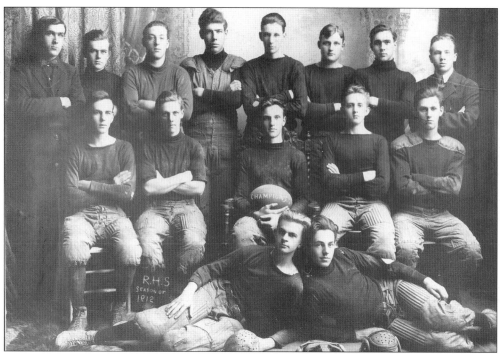

The 1912 Rockland High School football team. The two players in front with helmets and shin guards are "Dummy" Holbrook and Charlie Rose.

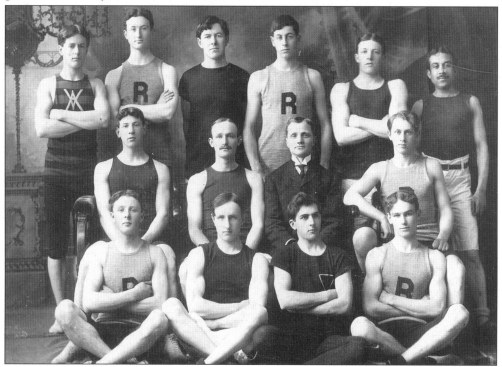

While early football and basketball team pictures are plentiful, views of an early track or cross country team, like this one, are much more rare.

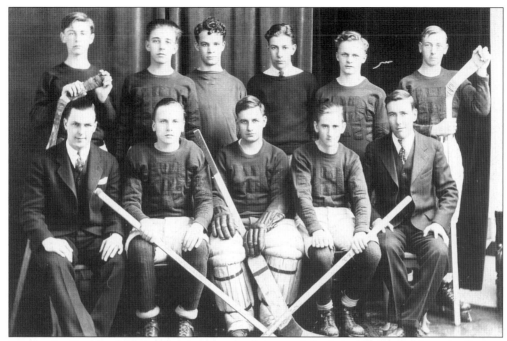

This is the Rockland High School varsity hockey squad, hailed as Knox and Lincoln County Champions in 1932. Ice hockey was very popular here in the 1920s and '30s.

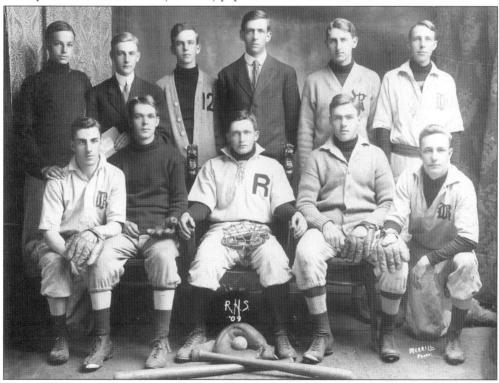

Jumping back to 1909, this is the R.H.S. baseball team, including our famous three-handed pitcher. Note the terrified catcher in the front center seat.

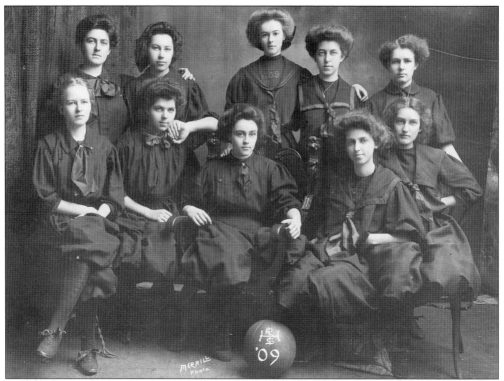

The 1909 Rockland High School girls' basketball team is shown here both carefully posed and beautifully coiffured.

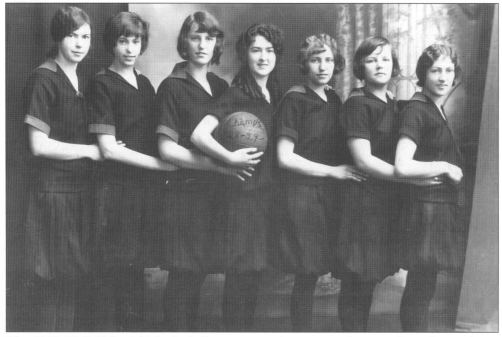

The 1928–29 R.H.S. girls' basketball team won the county championship, despite being hampered by bloomers and heavy sneakers.

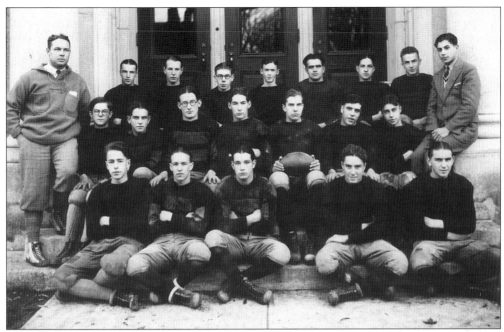

One of the Rockland High School football teams of the late 1920s posed on the front steps of the school. Rockland's beloved physician, Dr. Wesley N. Wasgatt, is in the front row at left.

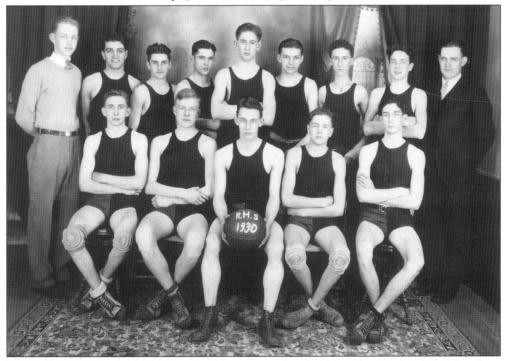

The R.H.S. 1930 basketball team contains so many familiar faces that we decided to list them here. From left to right are: (front row) Spud Murphy, Francis McAlary, Bob Gregory, Walt Gay, and Bill Ellingwood; (back row) Ken Crane, Steve Acardi, Paul Merriam, Frank Mazzeo, Alden Johnson, Bernard Freeman, Art Flanagan, Dick Knowlton, and Durward Heal.

Rockland has often enjoyed intramural sports by business-sponsored teams—a practice that has continued up to the present. This ice hockey team was sponsored, and perhaps coached, by Mr. C.E. Rising, whose contemporary advertisement for "First Class Bakery Products" appears above.

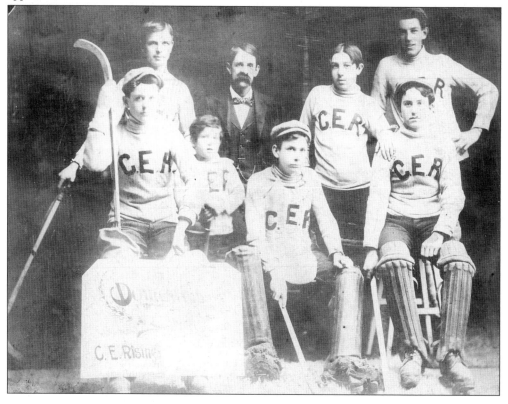

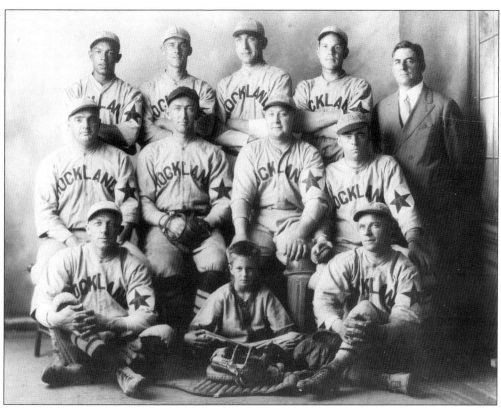

Rockland's Texacos, sponsored by Texaco and the A.C. McLoon Oil Company, are shown here in 1926. Mr. McLoon appears in a suit at right. The parade float below, also sponsored by Texaco, is from an earlier photograph.

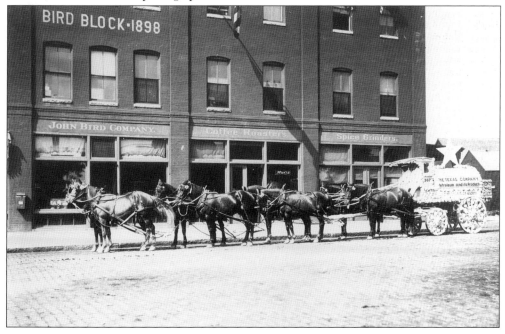

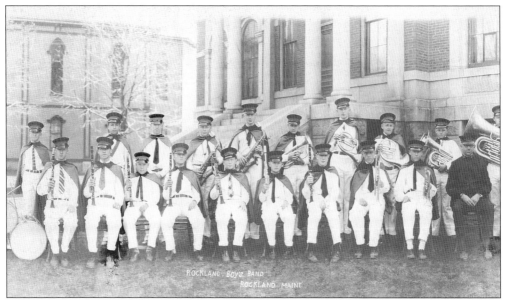

Bands have long played an important part at Rockland events. In the above photograph, members of the Rockland Boys Band pose in front of the Knox County Courthouse in the mid-1920s. This band graduated many members into the Rockland City Band, pictured below in the mid-1930s. These musical organizations were eventually replaced by school bands during the 1950s.

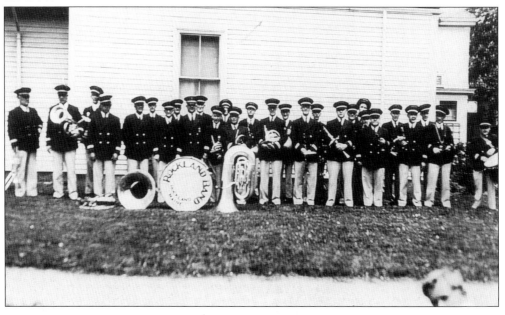

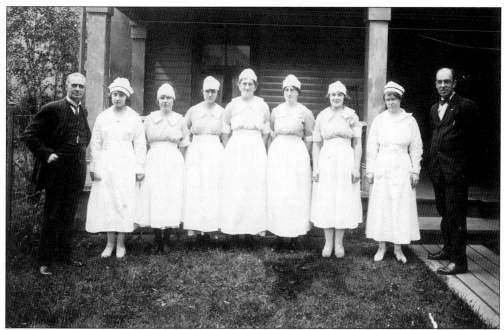

The staff of Silsby's Hospital pose in front of the hospital building. Dr. Silsby (at left) operated a maternity home and a hospital on Summer Street between Main and Union Streets. The seven nurses shown here in their best starched whites and caps worked at the hospital. At right is Dr. Frohock, another well-known Rockland physician.

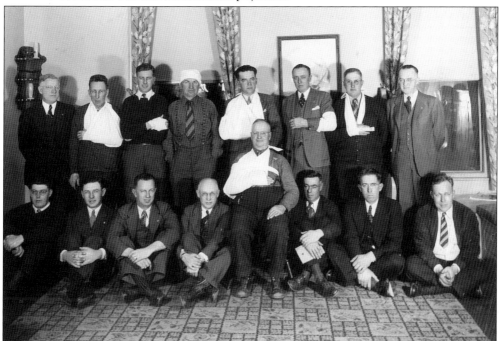

During World War II, everyone on the home front learned first aid. These employees of the New England Telephone and Telegraph Company's Rockland Office exhibit skills they have learned from first aid classes.

William T. Cobb, governor of Maine from 1904 to 1908, with his most notable political quotation. He was also one of the Barons of the Bay, heading the Cobb Lime Company for many years, and serving as president of the Eastern Steamship Company, the Androscoggin Electric Company, Bath Iron Works (during World War I), and the Camden & Rockland Water Company.

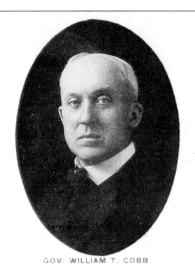

GOV. WILLIAM T. COBB.

"I had hoped to so conduct the affairs of my administration as to enjoy the confidence of my party and the respect of the people of Maine, but I will willingly forfeit both if they are to be won and retained only by forgotten promises and broken oaths."

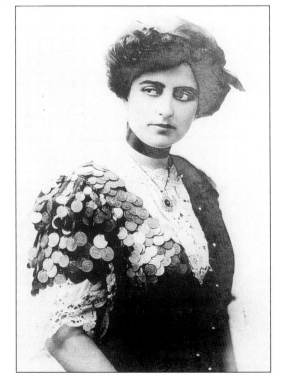

Maxine Elliott, born Jesse Dermot, is shown here on a popular postcard from the early 1900s. Many Rockland people have succeeded in their chosen careers, and a few Rocklanders have even been described as "rolling in money." Maxine, however, who had a notable stage career as a dramatic actress, is the only local person we know of who actually dressed in money. In this case, coins that have been sewn together serve as an overgarment to the dress.

William A. Farnsworth began his local business career with a general store in the 1840s. He later expanded into the lime industry, shipping, and served as a founder and early president of the Camden & Rockland Water Company. He became a prominent Rockland entrepreneur and another Baron of the Bay, and is remembered today much more than other local notables because his daughter, Lucy, left the family fortune of $1.3 million in 1935 to establish the William A. Farnsworth Library and Art Museum.

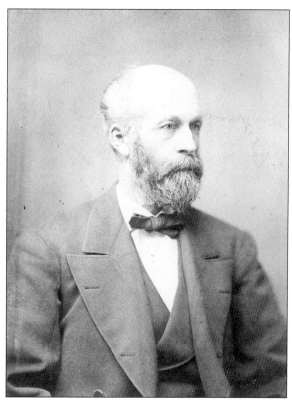

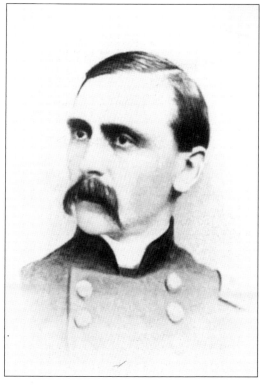

Adelbert Ames, born in Rockland in 1835, was a general during the Civil War. His bravery at the first Battle of Bull Run earned him the Congressional Medal of Honor, which was finally awarded to him in 1893. Ames graduated fifth in the Class of 1861 at West Point and, although wounded at Bull Run, he recovered and served the Union cause until 1866. After the war, Ames was provisional governor of Mississippi under Reconstruction, and later became a senator from that state. In 1898, he went back into the army and participated in the Santiago Campaign of the Spanish-American War. When he died at the age of ninety-seven in 1933, Adelbert Ames was the last surviving full rank general of the Civil War.

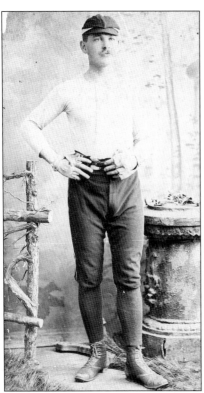

Frank W. Sanford, catcher for the Rockland Baseball Club in 1884, presented this portrait of himself to Parker T. Fuller, Rockland's assistant post master.

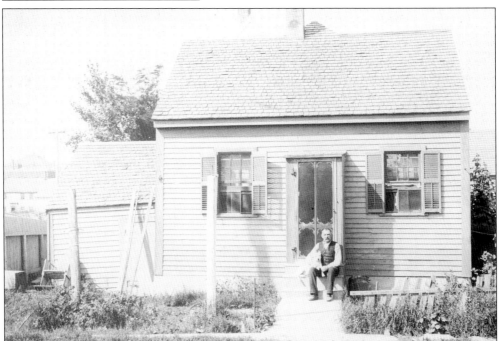

James Hartnet appears here in front of his beautiful screen door at 19 Pink Street with his dog. This late 1880s view describes him as a famous skater, but all we could find was a listing of him as a lime kiln tender.

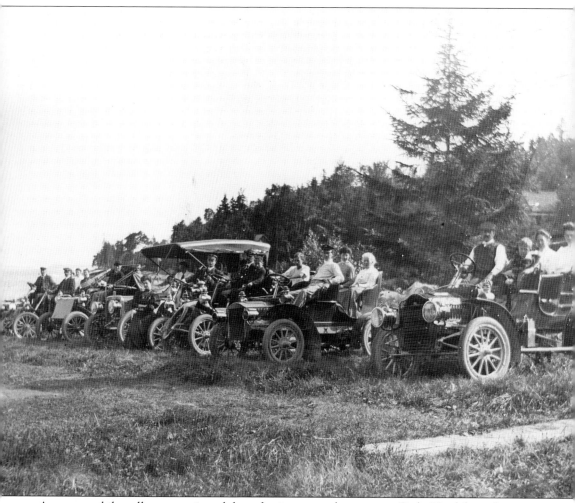

An automobile rally or touring club gathering near the present Owls Head line showing the popularity of this new mode of transportation in the era between 1910 and 1920. It was customary for local automobile enthusiasts to gather on Sunday afternoons and tour to a nearby town or other point of particular interest or beauty. One popular destination was the Crescent Beach Inn in Owls Head where they would meet for dinner.

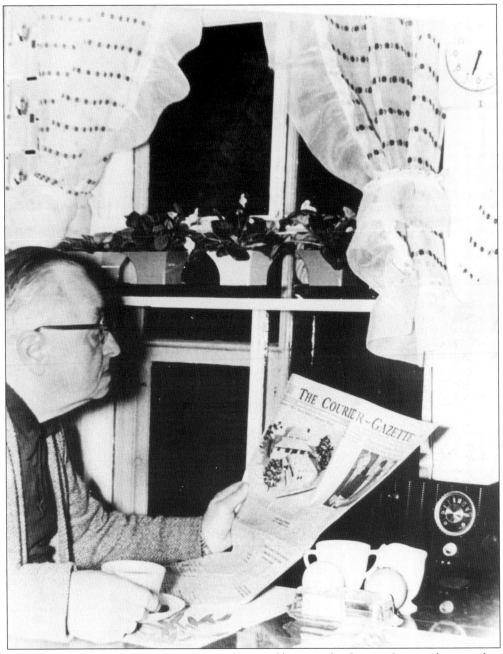

"Yesterday's news in tomorrow's paper tonight," a self-portrait by *Courier-Gazette* photographer Elmer Barde.

Seven

Other People, Other Views

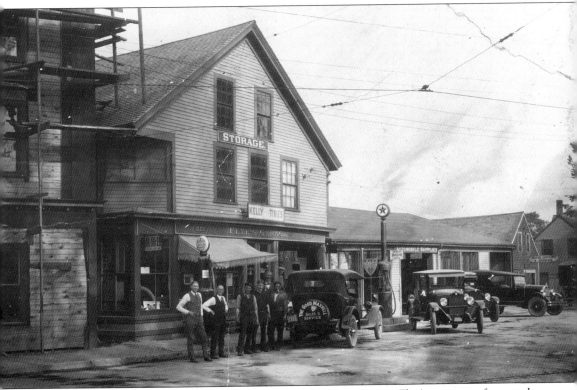

Five employees pose in front of Flye's Garage at 221 Main Street. Flye's was one of our early automobile dealerships and also sold gasoline from Texaco, as shown by the gas pump in the middle of the picture. Simmons' Horse Shoeing and Jobbing (to the right) demonstrates the contrast between the declining use of the horse and the increasing popularity of the automobile.

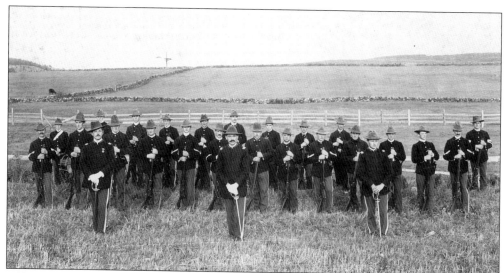

Tillson's Light Infantry lined up after a training session in a Rockland field, perhaps on General Tillson's property. This militia unit, formed after the Civil War, was named in honor of General Davis Tillson of Rockland. It was a proud company and membership was prized. Reactivated in April 1888, the unit was called to the colors when the Spanish-American War was declared.

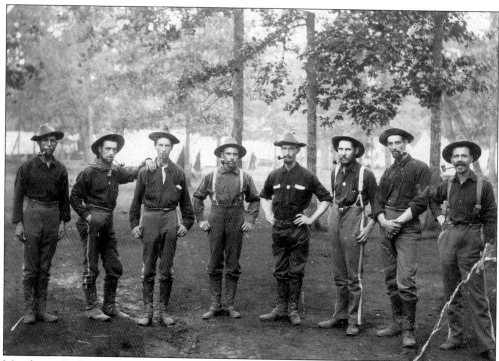

Members of Tillson's Light Infantry stationed at Chickamauga Park, Tennessee, in 1898. Shown here are, from left to right: Albert Hastings, Arthur Doherty, William Glover, Phillip Howard, William Graves, ? Pillsbury, Alton Small, and Herbert Thorndike. These men found themselves fighting typhoid fever and malaria instead of Spanish regulars and Filipino guerrillas. They were hit hard enough by disease that they were shipped home, not to battle.

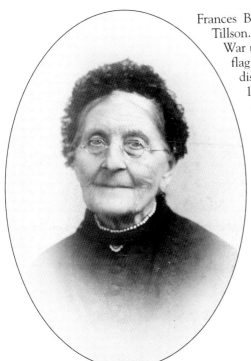

Frances Berry Orbeton, sister-in-law of General Davis Tillson. Mrs. Orbeton made a quilt from the Civil War uniforms of General Tillson and a Confederate flag brought home by the General. The quilt is displayed at Rockland's Shore Village Museum. In 1973 Mabel Ann Porter French of Camden said she vaguely remembered the quilt, but recalled very well her Great Aunt Elizabeth, who was the general's wife.

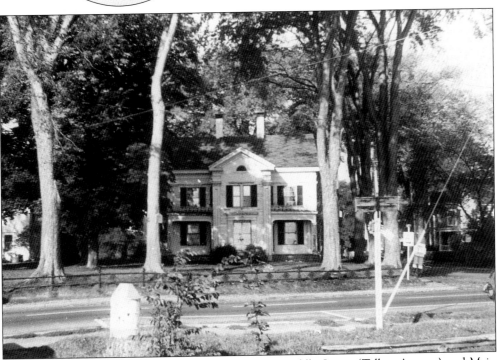

The home of General Davis Tillson at the corner of Middle Street (Talbot Avenue) and Main Street. The Tillsons moved here from their farm about three quarters of a mile west on Middle Street, because Mrs. Tillson did not like living so far out of town. The farmhouse is still standing on upper Talbot Avenue, but this mansion was torn down to make way for the Navigator Motel.

Vinalhaven & Rockland Steamboat Company
ROCKLAND

Service To:

Vinalhaven, North Haven, Stonington, Isle au Haut, Swan's Island and Frenchboro

Effective Sept. 16, 1941

FALL AND WINTER SERVICE
Eastern Standard Time
(Subject To Change Without Notice)

DAILY EXCEPT SUNDAY

Read Down	Read Up
A. M.	P. M.
5:30 Lv. Swan's Island,	Ar. 6.00
6.30 Lv. Stonington,	Ar. 4.40
7.30 Lv. North Haven,	Ar. 3.30
8.30 Lv. Vinalhaven,	Ar. 2.45
9.45 Ar. Rockland,	Lv. 1.30

When this schedule was in effect in 1941, the company's boats still used Tillson's Wharf.

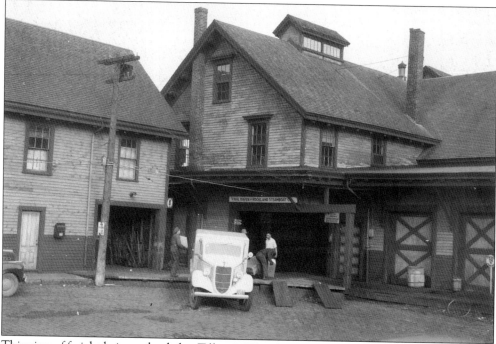

This view of freight being unloaded at Tillson's Wharf in the 1930s shows the departure point of island boats of the Vinalhaven and Rockland Steamboat Company. The sign on the right reads: "Boats to North Haven, Stonington and Swan's Island."

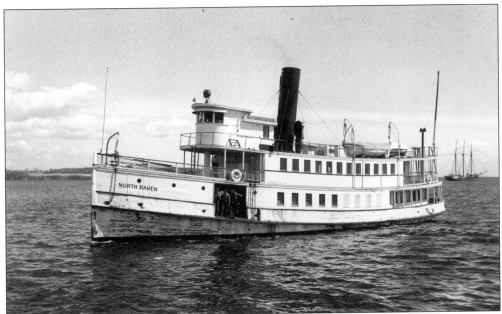

The steamer *North Haven* was one of the ferries for local island transport that used Tillson's Wharf in the 1930s. By the 1950s passenger steamers were replaced by modern automobile-carrying ferry boats.

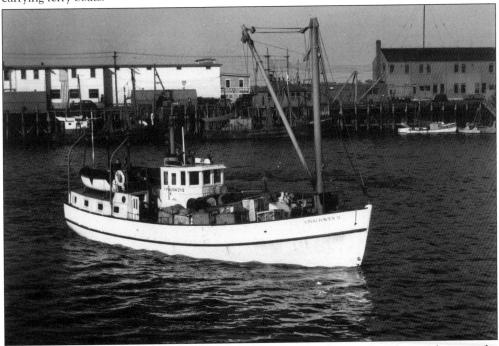

The *Vinalhaven II* in Rockland Harbor beside Tillson's Wharf, near where her predecessor, the *Vinalhaven*, sank in 1938. The *Vinalhaven II*, launched in 1943, was a transitional boat, neither a passenger steamboat nor an automobile ferry boat. For this trip she is filled with wooden barrels and crates, steel drums, and sacks, which were loaded and unloaded using the cargo derrick at the bow of the ship.

This photograph has a caption on the back which reads "Garbage on the Shore." Used as a dump during the 1920s and '30s, the area west of Lermond's Cove and next to Main Street was smoothed out to become Schofield-White Park in the mid-1930s, during the era of the Works Progress Administration.

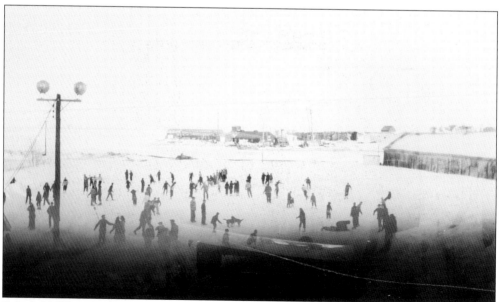

Schofield-White Park provided needed space for skating in winter, baseball and softball games in summer, and even chemical bomb fire-fighting demonstrations during World War II.

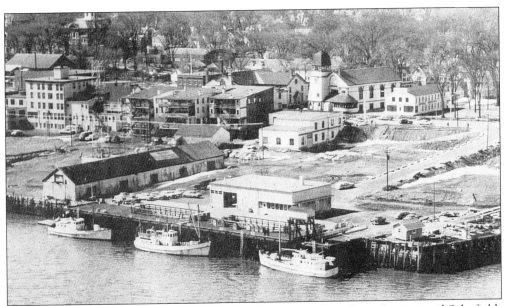

During the 1950s the Maine legislature created the Maine State Ferry Service, and Schofield-White Park was converted into a terminal for island boats that had previously used Tillson's Wharf (until 1943) and then McLoon's Wharf. The middle boat shown here is the *Vinalhaven II* (see p. 117).

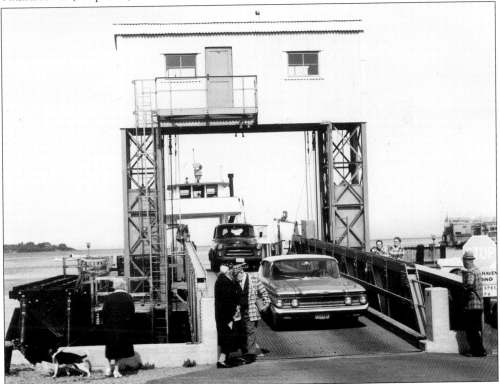

This picture shows the ferry slip at the former Schofield-White Park in 1962. The boat docked is the *Everett Libby* from Vinalhaven.

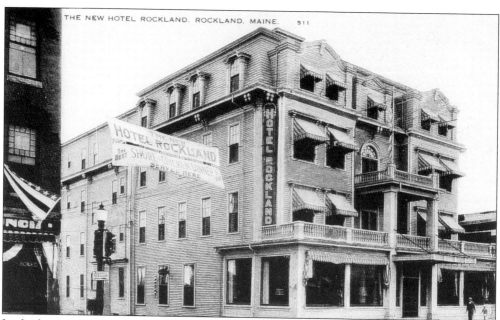

In the late 1920s, Rockland shoppers or visitors could choose either formal or informal dining within a few feet of each other. Pictured here is the "new" Hotel Rockland, shown earlier as the Lynde Hotel. It would be the primary victim of our million dollar fire (see p. 76). Note the banner advertising the "Best Shore and Chicken Dinners Served Here."

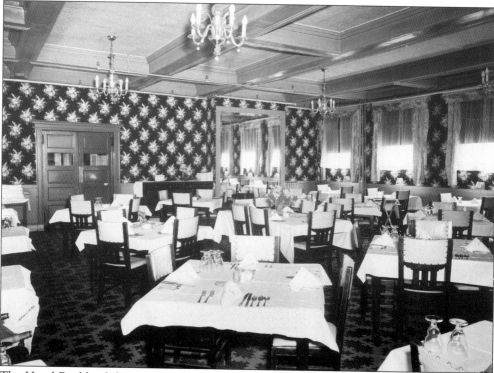

The Hotel Rockland dining room, with crystal and linen set for lunch or dinner, probably in the 1930s.

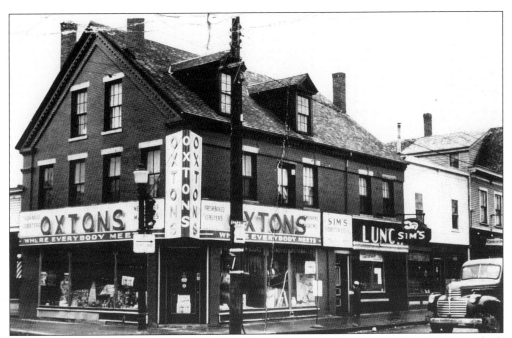

Just across Main Street from the Hotel Rockland was a small restaurant in the Fales Block called Sim's Lunch, shown here in the early 1940s. It boasted one of Rockland's first neon signs. This block burned in the fire of December 1952, and Sim's Lunch moved up Park Street to the corner of Union Street.

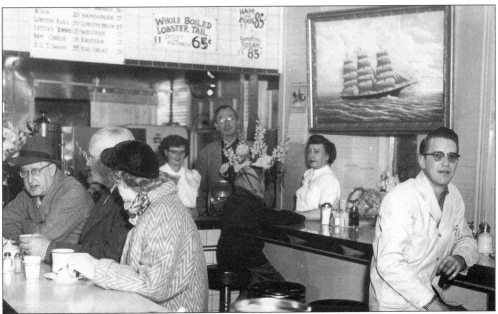

An interior photograph of the second Sim's Lunch at Park and Union Streets in December 1953. Founder Carl Simmons, standing behind the counter, continued to specialize in lobster rolls, which he had created at his first location near Main Street. Mr. Simmons has long been credited with inventing and promoting the lobster roll, a specialty which gained wide popularity and is still enjoyed today.

This page and the two that follow feature buildings now gone or places greatly changed. Shown here is the home of Hiram G. Berry, one of Rockland's Civil War generals. Formerly located on White Street, it was demolished to make way for the Bok Home for Nurses in the 1930s.

The Pleasant Valley Grange Hall on Talbot Avenue near Old County Road was previously a regional school known as Washington Hall. No trace of the building remains today.

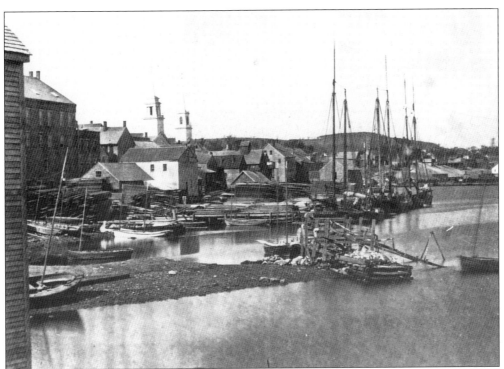

This view of Lermond's Cove is now the site of Rockland's wastewater treatment plant. The part of the cove where the Lermond brothers camped in 1767 has been filled in.

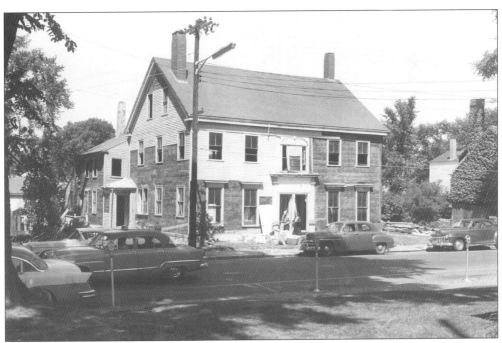

The duplex shown here, known as the Lillian Copping House (see p. 82), was razed to make way for the New England Telephone Company building at the corner of Limerock and Union Streets.

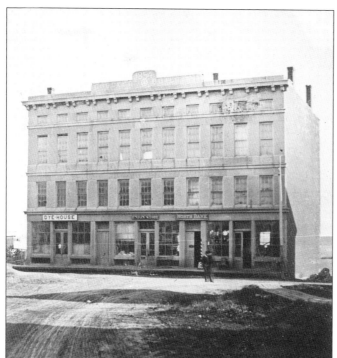

The Crockett Block on Main Street burned in December 1994. Its location was close to the shipyard where Rockland's most famous ship, the clipper *Red Jacket*, was launched. When the top floor of the building was removed in the early 1950s, the dated stone shown here was installed as part of the Fishermans' Memorial Pier at the public landing.

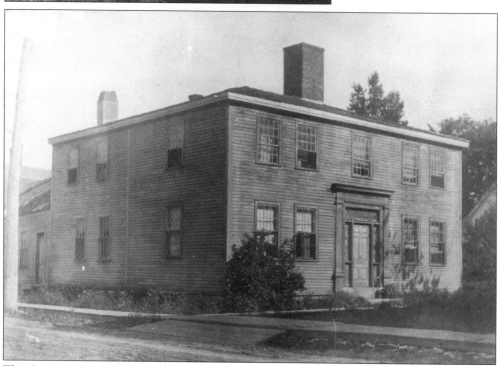

The Captain Jonathan Crockett House, built in 1800, sat facing Main Street in what is now a public parking lot on Tillson Avenue. When it was built, there were few houses or stores in this part of the Shore Village. The house was torn down about 1920, but the whole area is still called Crockett's Point.

From the previous pages of places changed, we switch to one very visible today. The Rankin Block appears today much as it does in this view from the early 1880s.

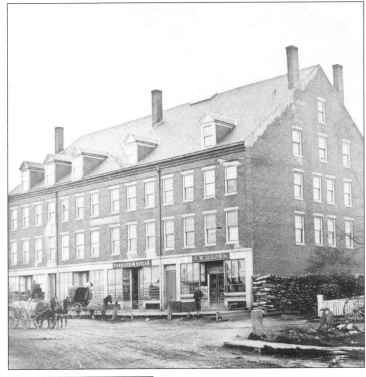

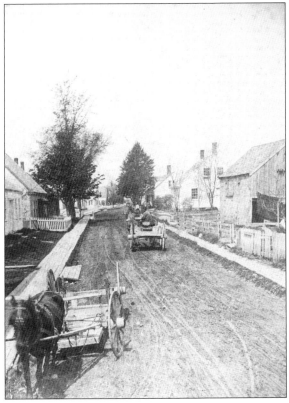

Rankin Street nearby is quite changed but still follows the same course from "The Rotary" of Main and Union Streets west toward our lime quarries.

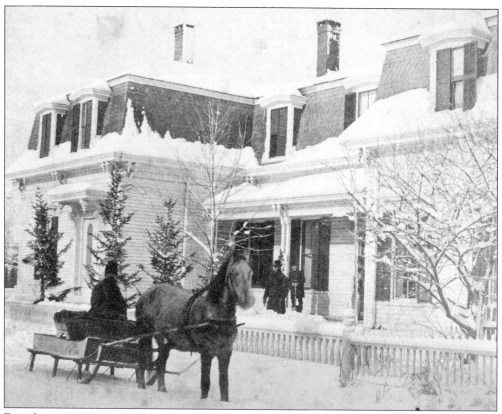

For whatever reason, old photographs of winter scenes are difficult to find. Shown here is the home of Job Ingraham at 11 Masonic Street in 1873. This house, now demolished, was for many years the Mandarin Dress Shop.

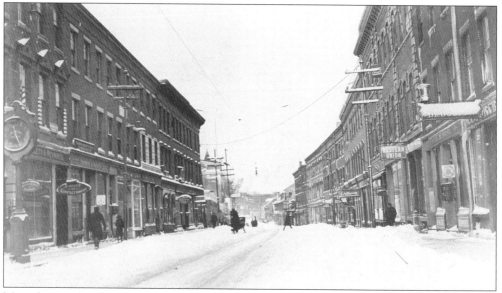

Main Street after a snow storm. This photograph was taken when horse and sleighs were still popular in winter, and the snow was rolled and packed, not shoveled out of the streets.

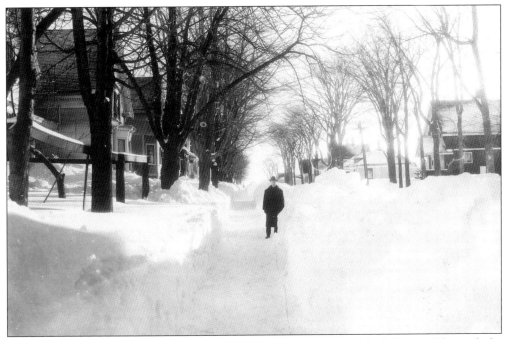

Broadway in February 1923, looking from Limerock Street toward Park Street. The path for travel seems too narrow for even the smallest of automobiles.

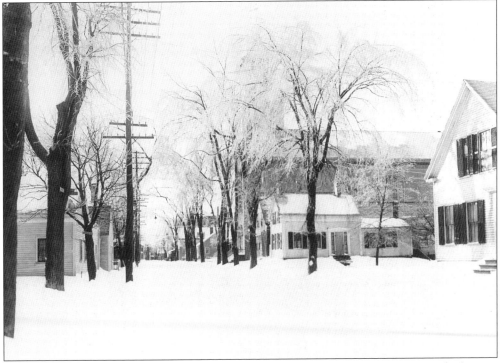

Union Street after an ice storm. Here in the Midcoast, this type of storm, with freezing precipitation that coats everything with ice, is the most beautiful—but also the most dangerous—of our winter weather.

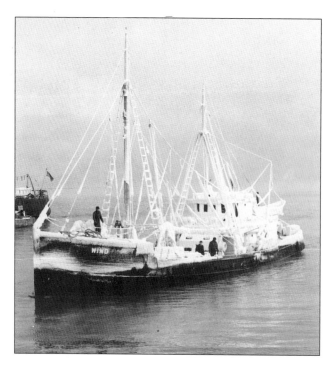

Pictured here is the *Wind* in Rockland Harbor on January 31, 1951. Her crew had been breaking ice on board since 4 am, in sub-zero weather, to prevent capsizing from the extra weight while she cruised back to Rockland. That month the *Wind* brought up in its trawling nets a huge eighteenth-century anchor off Mt. Desert Rock. This anchor was installed and remains on our Fishermans' Memorial Pier at the public landing. The *Wind* burned and sank off Nova Scotia in October 1951. All hands were saved, but the cook swore he would never go to sea again.

Acknowledgments

Around Rockland was a project of the Shore Village Historical Society. David Grima, Brian Harden, Barbara Perkins, Fourtin Powell, Harold Simmons, and Sharon Spaulding accomplished the primary tasks required. We called them the Book Committee. Each member of the committee contributed both time and material for the book and worked on the selection of photographs, arrangement of material, writing the captions, and editing. Special thanks must go to Sharon Spaulding. Besides participating in the selecting, arranging, captioning, and editing, she typed the whole text into her computer and made three <u>major</u> sets of corrections. So from Brian Harden and Barbara Perkins, who acted as editors of the project: THANKS SHARON. We could not have done this book without you! The primary source of material for this book was the James Burns Collection of the Shore Village Historical Society. Many of the best illustrations were loaned by the *Courier-Gazette*. Others, besides members of the Book Committee listed above, who generously loaned or donated material were: Eliot Gamage and Bertram Snow, who both contributed facts, figures, and advice, as well as material; Stephanie Clapp; and Frank Smith, whose donation of a collection of postcards and photographs enhanced the quality of this work. The Book Committee also wishes to thank Warren Bodine and the staff of the Reading Corner for allowing the committee to meet in the store's "back" room for so many weeks.